LAWRENCE WESCHLER

A TROVE OF ZOHARS

Also by Lawrence Weschler

Political Reportage
The Passion of Poland
A Miracle, A Universe: Settling Accounts with Torturers
Calamities of Exile: Three Nonfiction Novellas (Makiya, Kavan, Breytenbach)

Passions and Wonders
Seeing is Forgetting the Name of the Thing One Sees:
Thirty Years of Conversations with the Artist Robert Irwin
True to Life:
Twenty-five Years of Conversations with the Artist David Hockney
Robert Irwin Getty Garden
Shapinsky's Karma, Boggs's Bills and Other True-Life Tales
Mr. Wilson's Cabinet of Wonder (on the Museum of Jurassic Technology)
Boggs: A Comedy of Values
A Wanderer in the Perfect City: Selected Passion Pieces
Vermeer in Bosnia: A Reader
Everything that Rises: A Book of Convergences
Uncanny Valley: Adventures in the Narrative
Strandbeest: The Dream Machines of Theo Jansen
Domestic Scenes: The Art of Ramiro Gomez
Waves Passing in the Night: Walter Murch in the Land of the Astrophysicists
Flowers for Lisa: A Delirium of Photographic Invention (Abelardo Morell)
This Land: An Epic Postcard Mural on Global Warming (with David Opdyke)
And How are You, Dr. Sacks: A Biographical Memoir of Oliver Sacks

Recent Art Monographs
Deborah Butterfield * Tara Donovan * Liza Lou * April Gornik * Gerri Davis
The Richard and Mary Gray Collection: Seven Centuries of Drawings
Vincent Desiderio * The Art Guys * Michael Light * Eric Fischl
Fred Tomaselli * Mark Dion * The Oakes Twins
Matt Shlian * Jorge Tacla * Erwin Redl * Hans Noë
Federico Solmi * Tristan Duke * Jack Brogan * Kate Joyce
The Liminal Camera of the Optics Division of the Metabolic Studio
The Disappeared: Latin American Artists Confront the Dirty Wars
Further pieces on both David Hockney and Robert Irwin

Note:

This volume comprises the fourth entry
in Weschler's ongoing "Chronicles of Slippage" sub-series.
What *Mr. Wilson* did for the history of museums
and wonder, and *Boggs* did for money and value,
and *Waves Passing in the Night* did for the sociology of science,
A Trove of Zohars is endeavoring to do for
the early history of photography and
the long heritance of Judaism.

Being the incredible true-life tale of an utterly
forgotten mid-nineteenth-century
Lithuanian Jewish immigrant photographer
who spent his days documenting the
Lower East Side of Manhattan,

Shimmel Zohar

& of

Stephen Berkman,

the decidedly unlikely modern-day amateur
sleuth out of Pasadena, California, who almost
single-handedly rediscovered Zohar and his work.

As it were.

LAWRENCE WESCHLER
A TROVE OF ZOHARS

Shimmel Zohar, *Man with Downtrodden Banana*

April 23, 2023

Dear Samuel,

May your troves always be illuminated

xo

Rafael

In brimmingly fond memory of
Ricky Jay
our community's own
Wonder Rabbi

Contents

Zohar Studios

THE ROAD TO ZOHAR

I
In the Beginning

So I first heard about Shimmel Zohar from Gravity Goldberg (yeah, I know, but she insists it's her real name, explaining that her father was a physicist). Anyway, Ms. Goldberg, who is the Director of Public Programs and Visitor Experience at the Contemporary Jewish Museum in San Francisco,[1] was calling to apprise me of an upcoming show—an inaugural exhibition, that is, of a recently uncovered trove of work by Shimmel Zohar, a mid-nineteenth-century Lithuanian immigrant photographer (contemporary of Mathew Brady), who had chronicled the Jewish immigrant community of the Lower East Side of 1860s–1870s Manhattan in unparalleled detail, compiling a complete inventory of professions and types. Or not. There was, she suggested, some slippage in the whole story, and they were trying to find someone who might be willing to investigate things, perhaps even to provide an afterword to the tome that would be accompanying the show, which was almost on the verge of publication. And might I be interested?

I *was* intrigued.[2] Which is how it happened that, several days later—this was all a few months before the onset of our recent global pandemic—I found myself on a transcontinental flight out to Los Angeles to meet up with a fellow who, according to Gravity, had been involved in bringing the Zohar archive to the museum's attention. As

we flew over the Great Plains, I passed the time reviewing an early digital version of the exhibition's catalog with a growing sense of perplex.

Not that the work wasn't clearly brilliant, inspired, and often quite hilarious. And from the very start: a world turned upside down and decidedly at sea. "Predicting the Past" announced the title page, thereupon giving way to the volume's subtitle, "Elliptical Experiments of Reverse-Pre-science" (which was to say what exactly, the opposite of foreknowledge or rather of pre-science?). Specifically regarding "the Zohar Studios," zeroing in, to be more precise, on its "Lost Years." Dedicated, according to the following page, to all the dime-store mystics, lost (like those years?) in penny arcades. In concordance with the laws (the Laws, no less!) of wit and whim.

Following which, the volume launched into a procession of plush full-page sepia-toned images, not a few of them drop-dead gorgeous, many hauntingly nostalgic, and others (especially when coupled with their titles) deadpan drollarious. Beginning, by way of frontispiece, with a young advertising maiden, standing at earnest attention alongside the Zohar Studio banner on—could those be *roller skates*? On past a carnival barker showing off his spinning plates opposite the section title announcing "Plates." An intently dour madam (?) of indeterminate age (?), all swathed in black and hence perhaps in mourning (?), identified only as "The Baroness (?) of Babylon Boulevard (?)."[3] A woman hand-knitting a condom (inevitably as chock-full of holes as the story she seems to have gotten herself looped into). A man

The Baroness of Babylon Boulevard

holding forth a downtrodden banana (a rather large lump
atop his head, nowhere otherwise mentioned but perhaps
alluding to his own recent slip on said trodden peel).[4] A
pointillist painter with pinprick spectacles (which turn out,
once you get to the commentary several dozen pages later,
to be maybe for real and maybe not—there now beginning
to rise, here as elsewhere, and increasingly everywhere, a
leapfrogging sense of slippage). *Lazy Susan*, a lady so lazy
she clearly couldn't even be bothered to trim her own pu-
bic contrails, all the better for her greatest fan, some sort
of military commander—his own countenance framed by
truly spectacular sideburns, a scissors-medal affixed to his
chest—who'd somehow been able to procure a forget-me-

Man Revealing the Root of Evil

knot braid of the fine lady's cascading follicles. Conjoined Twins (speaking of further marvels of the hirsute), who clearly must have achieved their Siamese tandem-yoke sometime after puberty. Followed by a series of cures for hysteria, just when we might be beginning to feel a dire need for same ourselves.

A sailor with a stupendulous knot, about whom, we couldn't help but wonder as to whether he might ever have met the aforementioned good Lady Susan (oh happy day!). Another military commander, this one brandishing not so much a downtrodden peel as the root of all evil, and an actual root, at that. Followed by a perplexed gentleman, pondering the dread ventriloquist's puppet's head perched atop a stick at the end of his outstretched hand, which in

turn echoes an earlier instance of "Shtetl Shtick," wherein a seemingly downtrodden Hassid cradled a diminutive doppelgänger dummy on his lap—all leading to the age-old question (especially fraught, after all, when the enterprise is one of Predicting the Past) as to just who is the ventriloquist and who the dummy.[5]

Perhaps most hilarious of all, that earnest chemist painstakingly laboring across a maze of alchemical vials toward that latter-day philosopher's stone: a *non-humorous* laughing gas. Which of course leads to the Taxidermied Taxidermist, yet another dummy who's joined his dummies, a precursor conversely, of that delightfully somber little girl with her latent memory apparently being extended an outstretched primate nudge (life spawning life, after all, an intimation of the entire Darwinian Imaginary). And then Ricky Jay, the actual present-day sleight-of-hand master, haunted by some spectral visitor from the nineteenth century (or are we rather being given to understand that he is the one who has somehow been teleported back in time for this ghostly rendezvous?).

After which we are on to the "Foregone Conclusions," the first of which portrays a Blind Mohel (talk about foreskin concisions!) and the second a suave Merkin Salesman (perhaps for those other victims of that pube-collecting commander referenced earlier, though these particular pelvic toupees seem to have been fashioned out of iterations of said salesman's very own beard), and from there on to the Princess of Prussia, another little girl, this one with a face covered clean over with primate fur (although, here

Precision Dueling Team

again, as with the Merkins, both turn out to be based on actual historical instances, or so we will subsequently be given to understand).[6]

On past the group shot of a Precision Dueling Team, though perhaps not so precise after all, since it appears on closer examination that seven of its members are attending the funeral of an eighth.[7] On further, by way of Post-Humorous (a clown dog faithfully tending the corpse of his till-recently live clown master) and the six Victorian gentlemen crammed (like angels on the head of a pin) atop a sort of successor column to that of the daft fifth-century desert hermit Saint Simeon Stylites; and clear on through, finally, to an unexpurgated view of the studio of our apparent host, the mid-nineteenth-century Jewish New York master photographer, Shimmel Zohar, in the very act of photographing the roller-skate girl from that very first image,

Zohar at work in his studio, an apparent self-portrait

a revelation perhaps, there at the very end, of the blatant artifice attending all of it.

Or not. Or at any rate, *how?* Because, seriously, I found myself vesuviating, what the hell was going on here? Not that the dozens and dozens of pages of (mock?) pedantic, endlessly digressive commentary that followed seemed to help in the least. Because *Shimmel Zohar*—really, *seriously?* How come nobody ever heard of the guy till now?[8] And just who had been responsible for *his* posthumorous resurrection?

It was with questions like these spin-cycling through my head that I was now alighting at LAX, in pursuit of one Stephen Berkman of Pasadena, the guy who Gravity back at the Jewish Museum had suggested might prove useful in helping me begin to disentangle some of the mysteries fast proliferating around the entire venture.

A Wandering Jewess

II

If only things were going to prove that easy.

Berkman turned out to be living on a lovely leafy street of elegantly ranged single-family homes in the gently rising Dundee Heights neighborhood of northern Pasadena (in the lee of the towering San Gabriel Mountains, themselves fast rising just a few blocks further north), in what may have been the least elegant manse on the entire block. The front yard's xeriscape was shall-we-say a touch overgrown and there were two cluttered pickup trucks slotted into the front driveway—"Yeah," explained Berkman as he now emerged from behind the far gate, "my life partner Jeanine bought the first, and I thought it was great so I got myself one, too." Berkman proved a shortish fellow with a joshingly amiable demeanor, a pair of disconcertingly bushy muttonchops framing his otherwise welcoming face. "Dundrearies," he clarified helpfully, gauging my disconcertion. What? "The technical name for this kind of sideburn, very popular in the Victorian era, named after Lord Dundreary, the clueless upper-class twit in Tom Taylor's hit play of the time, *Our American Cousin*."

Berkman's own pair, at any rate, were to conventional sideburns as a conflagration would be to a campfire. They dangled well past his clavicles, giving Berkman something of the out-of-time appearance of a genial garden gnome. (He subsequently told me how once, during the selection process when he'd been called for jury duty, the prosecutor queried, "How long have you been growing those things?"

Edward Sothern as
Lord Dundreary

to which he answered, "Oh, since I was three." At which point not only was he selected for the jury, but he was subsequently elected its foreman!)[9]

Berkman now bid me follow him into the back of the property, through an opening in a dilapidated wooden fence, and if the front of the house had seemed somewhat overgrown and ramshackle, what we now entered was positively a boneyard, strewn with all manner of truncated mannequins, empty mangled cages, toppled Corinthian columns, a papier-mâché hermit's cave, warped planks of plywood, disintegrating plaster cornices, variously disabled gadgets, and mysteriously jumbled piles of knick-knack bric-a-brac buried under massive black tarpaulins—"Yeah," Berkman apologized as we clambered our way toward an alley cut between two outbuildings, his library-cum-studio hangar to one side and a converted-garage darkroom to the other. "I have a friend who describes this area back here as looking like the kind of thing that would happen if a passing FedEx cargo plane accidentally jettisoned its payload. But here is my main workspace," he continued, at which point I interrupted to ask if I could first use his bathroom. "Oh sorry, of course." We doubled back to a side entry into the main

house and he pointed the way, advising, "But be careful, the door has lost its handle," in what would prove the first of many such comments, any one of which could easily have served as an alternate title for this entire essay.

Having completed my business, I wended my way back to the side entry into Berkman's atelier, which now proved a dim cavernous den and veritable hoarder's paradise, one that made the outer patio seem pristine by comparison. Off to the sides, vast bookshelves groaned under the weight of arcane volumes on nineteenth-century photographic techniques;[10] rickety tables were covered over with ornate optical and musical contraptions in varying stages of disassembly; cardboard boxes overflowed with Victorian costumes, stuffed animals, ornate banners, splendid haberdashery, and comatose puppets, with thick serpentine cables coursing underfoot and thick cascading wigs dangling down from somewhere in the rafters up above. "Be careful about putting anything down over there," Berkman advised from the distant northwest corner of the hangar, where he was puttering about in a relative aquarium of light, framed by wide skylights and a wall of gridded windows and folding-glass doors—a carefully worked-out replica, it momentarily seemed, of Zohar's own studio as it had been portrayed in that last of the book's plates. "Otherwise," Berkman continued, "you probably won't be able to find it for months."

Somehow I surmounted the intervening clutter and made my way over to the open space there in the corner, where Berkman had taken to tinkering with a big wooden camera mounted atop a wide-sprawling tripod, at which

point I took my seat in the elegant wooden chair at the far end of the camera's regard. So listen, I began ("Wait a second," Berkman interrupted, "let me get a chair for myself," whereupon he delved back into the clutter-chaos, "You'd think I'd be able to find a chair in here somewhere," he bellowed from deep inside, emerging a full minute later with a rickety stool). Listen, I recommenced, I'm going to want to get into this Zohar fellow in a moment, how you became aware of him, and more exactly who he is to you, or you to him, none of that is quite clear in the book. "Ah," said Berkman, raking his Dundrearies in consternation and shifting nervously atop the stool, "that's all a very complicated situation, perhaps the less said the better."

Okay, we'll get back to that, I persisted, but maybe we could instead start by his just telling me a bit about himself. For starters, when and where had he been born and into what sort of family? "Well, I was born in 1963, in Syracuse, New York—we all have to be born somewhere—though our family moved out to Northern California the very next year, to Santa Rosa and then to Redwood City. My parents were both very engaged with their Jewishness—conservative, the family kept kosher—their parents all having emigrated from Lithuania, fleeing pogroms, back in the teens and twenties, and all of that generation spoke Yiddish. I have memories of my paternal grandfather in the hammock out in the backyard, keeping up with the latest developments in the Watergate scandal by way of the Yiddish newspaper *The Forward.* He had been a shochet, a ritual butcher, and my mother's father worked at General Electric (he'd received

a master's degree in economics from Harvard Business School). My mother, Marsha Lee, is a writer (who more recently got a doctorate in Jewish studies from Spertus Institute in Chicago), and my father, Norman, is a CPA, still practicing. He in fact would become the CPA to a whole succession of famous performers—for example, Joan Baez, who became a family friend and for my bar mitzvah gave me a Rolling Thunder Revue T-shirt, which I believe I still have, somewhere back there." He started to get up to look for it, but I said, Never mind—I believed him.

Berkman himself had not been particularly seized by Jewish themes in his early days—"Hebrew school was an existential trial"—but even so, he went on to tell me how, being the only Jew in a goyishe surround in elementary school, he had a sense of difference from others early on, they and their families were somehow clearly not like him and his, as a result of which he began to develop a sense of himself as an outsider, which he came to cherish. He was middling-decent in school, given to passionate immersion in the things he cared about and utter indifference to most everything else. At age five he received a microscope as a present and dove deep—not so much with regard to the things one could see through the scope as to the optics of the thing itself, and presently to optics generally. His family didn't have many art books, but like many families at the time, they did own a copy of the best-selling *Family of Man* catalog from the photography show at the Museum of Modern Art, and there, very early on, he became transfixed by Wynn Bullock's unsettling

picture of a naked child face down in the forest—an early instance, Berkman said, of his taste for the enigmatic, which left space for the viewer's imagination to do its own work, and presently by photography more generally as well, especially after, by age eight, he came to understand that one could process photographs oneself, one didn't always have to take them to the drugstore for developing. By ten he had his own Kodak 110 camera and started experimenting with 35mm stills in a rudimentary darkroom, and almost from the start he had a sense of time itself as somehow being the true focus of his passion—both how it was captured and how it was represented in the photographic enterprise, "the way how to this day, the moment the seized image swims up from out of the dark feels utterly magical."

Shortly after that, back in Hebrew school, which up to that moment had completely bored him, the teacher, Mr. Kaplan, began projecting 16mm films of the Holocaust and discussing the shtetl life that had preceded and been extinguished by it, and young Berkman grew completely entrammeled. "Strange, that," he observes, "how in that sense my growing interest in photography—in this case in moving pictures—was virtually simultaneous with the dawning of any real interest in Judaism, though in a cultural rather than any religious sense, and in particular in the shtetl culture of Eastern Europe before the Holocaust and back into the nineteenth century. For that matter," he goes on, "I think a good part of what would become an all-consuming interest in the nineteenth century for me

grew out of the fact that it was the century when chemical photography was itself being invented."

A few years later, the last year of junior high, Berkman discovered a stash of comic silent films in a back closet at the school and decided to run for student body president on a platform solely given over to projecting them for free at lunchtime. He lost badly: "an early instance," he comments nowadays, "of my pattern of uncovering things, trying to popularize them, and nobody really caring." But in general, he insists, his was a happy childhood, devoid of any real traumas or hardships. "I mean, I was short—at the end of high school I was voted the shortest in my yearbook, when what I'd really been going for was best hair—but I got along with people and was well liked, nothing really to complain about, I've never had to go in for therapy, no dark wells of anguish, the sort of things that other artists seem able to draw upon for inspiration, which may explain, for example, why I have so much trouble fleshing out any sort of alter ego."

We'll get to that, I assured him. But just rounding out his own story first, what about his initial vocational intentions and subsequent schooling? "Well, by fifteen or sixteen, I'd pretty much decided on a career in photojournalism and was even contributing photos to local newspapers, including the *Times Tribune* and the *San Francisco Examiner*, and hanging out with the guys in their photo departments, who kind of took me under their wing. Though on a separate track, I was getting more and more interested in nineteenth-century photog-

raphy, and I remember how even then I was spending a lot of time thinking about whether it would be possible to replicate old lenses and cameras and chemical compounds so as to be able to create new images exactly the way the pioneers had done."

Funny, then, how when he reported to college at San Francisco State University, his education went in neither of those two directions. He majored in film, but in cinema rather than photography, and even though he steeped himself in the work of such relatively recent experimental masters as Alejandro Jodorowsky and Kenneth Anger and Max Ernst and Larry Jordan and Harry Smith (the latter three of whom, granted, had regularly folded collages of nineteenth-century graphic imagery into their decidedly hermetic short films), by the end of his time there he'd convinced himself that what he really wanted to aspire to were more conventional narrative feature films pitched to wider audiences, which in turn is why he pursued that angle, moving over from SFSU to study film at De Anza College in Cupertino, which is where he met Jeanine Tangen, a Minnesotan of Norwegian stock, herself just out of the University of California at Santa Cruz (where she'd received a degree in photography), in their very first class—and the two have been together ever since. They shared a whole range of interests and intentions from the outset, transferring together to Art Center College of Design in Pasadena the following year for further studies. She went on to a successful career as a writing assistant to directors of both longer and shorter films, and for his own part, Berkman,

while now teaching as well at Art Center, began directing commercials and music videos, the initial rungs on the conventional ladder toward more ambitious feature projects.

Except that his heart wasn't really in it. He (and now Jeanine alongside him) kept being pulled back into the nineteenth century and in particular the astonishing first sixty years of still photography, "when all the subsequent genres were being developed right there before your eyes and from the very start." (Jeanine was likewise being drawn ever deeper into Stephen's obsession with the Eastern European Jewish history of that same era. "Notwithstanding her Nordic roots," Berkman assures me, "she knows more about Judaism than just about any Jew I know.")

By 1995 (Berkman would have been thirty-two years old) he was a paid-up member of the Daguerreian Society. He and Jeanine made a pilgrimage to Saint-Loup-de-Varennes, a few hundred kilometers southeast of Paris, where back in 1826, Nicéphore Niépce, deploying the heliography technique that he'd just perfected, achieved what is considered the very first proto-photograph, a fuzzy-hazy rendition of the view through an upper story window looking out on the roofs of his Le Gras estate. ("The estate is open to tourists," Berkman reports, "and at one point we went upstairs to the very window, the very view, it was an incredible experience, and I was getting set to memorialize the moment by snapping a photo when Jeanine nudged me, pointing to the large sign over to the side absolutely forbidding photography of any sort. Ironic, I know.")

Around the same time they were also overwhelmed

Joseph Nicéphore Niépce, 1826-27,
Le Point de vue du Gras, heliograph

by a big exhibition at the Metropolitan Museum in New York of the photography of the early French master Nadar, and by the extraordinary detail and haunting tone that the wet-collodion technique he championed had afforded him, such that, returning to Pasadena, Berkman re-equipped his darkroom and began experimenting with that technique himself. "I think of myself as an early bloomer who got a late start," Berkman likes to say, and even though the wet-collodion process was itself superseded by other methods in the 1880s, it remains the main technique he himself deploys to this day.

Meanwhile, his darkroom facilities expanded considerably a few years later when he and Jeanine acquired their current compound ("right around the time the U.S. invaded Iraq the first time"). In addition to the house's

other attractions, they couldn't help but notice that it was situated near the corner of Fiske and Woodbury Streets—George Fiske (1835–1918) having been a pioneering American landscape photographer and confederate of Carleton Watkins; and his near exact contemporary Walter Woodbury (1834–1885) having been an English photographer of Australia and the Dutch East Indies and the inventor of the break-through photomechanical process that bears his name. One could hardly have asked for a more auspicious location.

Delacroix, by Gaspard-Félix Tournachon (Nadar), 1858

Chemist Developing Non-Humorous Laughing Gas

III

"Here," he said, "I'll show you how the wet-collodion process works." He checked a few final details on the large boxy wooden camera atop its tripod and then, sliding out the empty plate holder from behind the camera's rear, he ducked under the black hood and gazed upon the frosted glass panel onto which the lens at the front of the camera was now projecting an image of me, upside down. He re-adjusted my pose, had me try a few variations, settled on one, and slid the accordion bellows leading out to the front lens forward and back a few times, tweaking the focus, till he had everything just right. "Okay," he said, "first we have to go prepare the glass plate," at which point, empty plate holder in hand, he led me outside through the folding glass doors and across the narrow alleyway into his darkroom, which was if anything even more cluttered than the library warehouse, only pitch black, a narrow passage winding through the clutter flanked on both sides by all manner of treacherously jutting objects and variously precarious vials. "Be careful," Berkman cautioned (another great potential title), "and try to follow in my footsteps. *Walk like me*" (even better).

Once we'd made it over to the workbench/sink on the far side of the darkroom, Berkman flicked on a dim light, set the empty plate holder over to the side and reached down into a square wooden storage box on the floor, gingerly pulling out a single clean, polished pane of glass, just a little smaller than the entire rear of the camera back in

the studio, which he now proceeded to clean and polish a bit further, as he explained how "the wet-collodion process was developed in England in the early 1850s and represented a considerable advance on the daguerreotypes and calotypes that had immediately preceded it. For one thing it allowed photographers to generate paper copies of the original image in magnificent detail, with exceptionally lush tonalities and in previously unheard-of quantities. And key to the process was this," he now reached over to a jar of a red viscous liquid that looked a bit like thickened cherry Kool-Aid, swishing the contents around a bit. "This is the collodion mixture, made from a carefully calibrated blend of collodion, which is basically guncotton dissolved in nitric acid (and is otherwise used in various medical contexts to this day), mixed with anhydrous ether, 190-proof alcohol, along with tinctures of potassium iodide and cadmium bromide—I mixed up this particular vintage about a week ago and then left it to settle and cure—here," he unscrewed the lid, "Smell it," and indeed the brew evinced a certain sharp medicinal trace. "The first time I got a whiff of collodion," Berkman confessed, "I was hooked for life. Really it was a transformative experience." How so? "The scent was both sharp and sweet, but with dimension, with depth. In fact it transported me clean back to one of the peak moments of my childhood, when I was first exposed to laughing gas at my dentist's. I remember thinking at the time, Gee, wow, how many more cavities do I have to get to be able to experience that again? Which in turn reminds me of the story I read somewhere about how when Roget,

Zohar Studios Plate Box

the creator of the thesaurus, first experienced laughing gas, he couldn't think of *a single word* to describe its effect.[11]

"Okay," Berkman reverted to the business at hand. "Now we take the pane of glass, and carefully hold it out by its edges, horizontally like this, and we pour a puddle of the collodion mixture onto the center of the glass—as you can see the stuff's like a light syrup and quite sticky, which I tend to associate with ectoplasm (which I in turn always think of as being a conduit for spirits)—anyway, we gently tilt the pane back and forth, like this, so that the puddle spreads evenly over the entire surface, and this will serve as the binder for the next step, in which we now dip the treated glass pane like this," he opened a narrow wooden box off to the side, "into this silver bath, a solution of distilled water with nine percent silver nitrate, we close the box's lid and leave the collodion-sheathed glass in there for about

four minutes to absorb a layer of evenly diluted silver, the layer which will in turn presently absorb the light pouring through the lens bellows when we put the treated glass back into the camera."

While we waited out the four minutes, Berkman mentioned how in addition to the aroma of the collodion mixture, he had likewise been drawn specifically to the deployment of glass negatives in the wet-collodion process. "I've already mentioned how utterly magical the whole procedure continues to feel to me to this day, this arcane secret activity undertaken in the dark—but it also struck a specifically Jewish, or rather Jewish mystical, a Kabbalistic chord in me, back in those days when I was delving deep into shtetl culture at the same time. Which is to say, the shattering of the glass vessels at the beginning of Creation."

This happened to be something that I too had studied back in the day, in college, the way that a major question for the Kabbalists of the sixteenth century, especially those gathered round the great Rebbe Isaac Luria (1534–1572) in Palestine, was how Yahweh could ever have created anything, since he was already everywhere and there was hence no room for anything else—a conundrum they resolved by suggesting that just before the Creation, Yahweh breathed in, as it were, through a process called the *Tsimtsum*, absenting himself from a portion of his cosmos,[12] where he'd set up a sort of apparatus consisting of ten great interconnecting glass vessels, into which he would now be aiming the overwhelming light of his power and beneficence as a first step in the Creation[13] —only, some-

thing went disastrously wrong, the glass vessels could not contain the sheer intensity of the light surge and shattered into billions of tiny shards that now drifted into the dark abyss, this all being another way of thinking about the Fall, a Fall that somehow left Yahweh in a certain sense wounded as well, such that He can no longer repair things on His own, and it becomes the work of humans in this world, through *Tikkun olam*, a sort of contemplative action across time, to help mend the world.[14]

"Yeah, right," Berkman concurred after I offered my summary, "so that maybe you can see how the collodion process—this near-alchemical devotional activity,[15] blending themes of light and dark and glass and breakability—might have rhymed with some of those other growing obsessions of mine."

"Okay," he continued, "that's been about four minutes. So now we have to move quickly, because once we pull the glass plate out of the silver bath (and even in this dim light you'll see how the sensitized pane has turned a sort of cloudy milky white, evenly spread over as it now is with all those minute suspended silver particles), we have to accomplish everything else—placing the plate into its light-tight holder, taking the holder back to the camera and, pushing aside the hinged sheet of frosted glass, installing the plate holder in its place at the back of the camera, getting you all set up again in that pose in your chair, pulling aside the dark slide separating the plate from the accordion bellows and removing the cap from the front lens, thereafter exposing the plate for about forty sec-

Stephen Berkman behind the camera

onds during which you'll have to keep as still as possible,
sealing things up again (the lens cap and plate holder's
dark slide), and bringing the light-tight holder right back
here to the darkroom for development, which involves a
whole other process—and all of that before the plate's sil-
ver-fused collodion skin dries up, after which it becomes
useless. Which is to say we'll have about ten minutes total.
(That incidentally was why traveling photographic entre-
preneurs back in the 1860s and 1870s had to journey about
the country in the company of cumbersome horse-drawn
darkrooms, so they could do everything right there on
the spot.)"

All that being pretty much what then happened: Berk-
man carefully extracted the plate from its silver bath and
gingerly placed it into its holder, which he now sealed up
light-tight, and somehow we made our way, maneuvering
even more painstakingly through the darkroom clutter-
maze and back to the studio, where, as Berkman, intent,
his Dundrearies veritably shivering, slotted the plate holder

back into the camera, I resumed my pose, tilting my face just so and breaking into what I fancied to be a fetching smile, whereupon Berkman looking up suddenly shouted, "*No smiles!* This is serious business! Happiness is not part of the equation. Seriously, things never work if you smile!" (four other great potential alternate titles, come to think of it, one right after the other). I sobered up and froze, he removed the cap and tapped a stopwatch, which proved not to be working, so he just said "Now" and dove under the black hood at the rear of the camera, as the world seemed to hold its breath, stock still, for a seeming . . . eternity. He counted down to forty, *using Roman numerals* (or so I inferred of the muffled voice emerging from under the cape—with me doing my level best not to burst out laughing), after which Berkman sighed, emerged from under the cape, replaced the cap, retrieved the plate holder, and back to the darkroom we raced.

Once back at his darkened workbench, Berkman gently nudged the exposed plate out of its holder and began performing all manner of ablutions as he slid the thing from one bath and rinse to the next (developer, fixer, and so forth).[16] For my own part, watching the image, my own image, slowly swim into being from somewhere seemingly far, far behind the transparent glass pane, was, as Berkman suggested, a quite spiritually tinged and even soulful experience. And furthermore, the image that emerged seemed to be coming from somewhere way back—indeed, as if I myself had been teleported back to the nineteenth century. Or rather, maybe, it seemed simultaneously age-

less and yet possessed, conversely, of exceptional presence and immediacy. Stammering, I tried to express all of this to Berkman, and he replied, "Yes, what it has is *duration*. It has time in it: not least the time of your sitting there." He paused, shaking some of the distilled water rinse off the finished plate, before continuing. "Cartier-Bresson liked to speak of the Decisive Moment that he was always pursuing in his still pictures, but if you think about it, how much time was there in all of his shots combined? What, a tenth of a second here and two-tenths there, maybe in total a full minute's worth across his entire career? Whereas this single image has forty seconds. No wonder it catches and holds us."[17]

He placed the glass plate on a rack to let it finish drying ("Maybe we'll try a few more tomorrow," he suggested), and we headed back to the studio. So listen, I now queried as we settled back onto our respective seats, when exactly did what had been a hobby off to the side of his commercial and filmmaking and teaching careers flip places, with those careers falling back into a secondary role as mere financial supports for what was fast becoming his true passion, this sort of photographic activity? He guessed that would have been in the late nineties, maybe 1997 or 1998. "I mean, I remember even earlier, in the mid-eighties or so, going to see the conceptual artist Chris Burden's show at the Laguna Art Museum, filled as it was with references to all the intellectual backdrop of his conceptualizing, terrific show, and already then I remember thinking, *Hell, I think about that stuff all the time.* But by the late nineties, out on my

commercial shoots, for example, I found myself increasingly thinking that all I really wanted to do was get back home so I could bury myself in the latest issue of *Collodion Journal*"—of which, yes, there *is* a *Collodion* quarterly. "Granted, within a few years I had managed to figure out a way of blending those two sides of my life, at least part of the time, starting with a job where I got hired to join Anthony Minghella's shoot of *Cold Mountain* on location in Romania as supplier of wet-collodion tintypes for its American Civil War scenes"—Berkman subsequently noted how at the time he'd felt like an itinerant Civil War photographer, carrying his heavy equipment across vast fields where uniformed soldiers reenacted battle scenes with vats of diesel fuel burning to blacken the sky and explosions and artillery all around, only to be picked up at the end of the day by a personally assigned car and driver who returned him to his hotel—"and from there that sort of hybrid activity became an increasing source of livelihood." (Since *Cold Mountain*, Berkman may have become Hollywood's leading go-to man for those sorts of plot-driven antiquarian photographic portrayals, in films ranging from *The Assassination of Jesse James* and *Bury My Heart at Wounded Knee* through *Batman v Superman* and *Wonder Woman*, producing collodion and similar style tintype portraits of stars ranging from Johnny Depp, Brad Pitt, Jude Law, Sam Shepard, and Ricky Jay through Nicole Kidman, Gal Godot, Natalie Portman, and Anna Paquin, among many others. He even had a bit part himself as a traveling Jewish photographer in *The Lone Ranger*.)[18]

Shtetl Shtick

IV

But and so okay, I now doubled back, hazarding: 1997, '98, '99. The people at the Contemporary Jewish Museum tell me that this upcoming show devoted to the Zohar Studio is going to be the culmination of over twenty years of your lifework. So it must have been somewhere in here that, how shall we put it, Shimmel Zohar first entered your life. How did that come about?

Berkman looked back at me, thrumming his Dundrearies, non-comprehending.

Seconds passed: talk about duration. "I don't understand the question."

Well, how did you first hear about him? I mean, it clearly must have been quite a discovery.

"Well, yeah, but that's the kind of thing I'd really rather not go into. It's a complicated story and not all that interesting, and I don't want to call attention to myself. I don't want to get in the way of Zohar's achievement, the studio's story. I merely think of my role as being a kind of facilitator in bringing that story to the world's attention."

A facilitator? What does *that* mean? (Now it was my turn to look back at him, non-comprehending.) I mean, the book begins with a procession of remarkable images: Where did you find them? What's their backstory?

"I didn't 'find' them exactly. This book is my tribute to the work of the Zohar Studio and the historical imagination."

Okay. Your *tribute*? There's that "Somnambulist's Guide to the Photographs," the long, long swath of commentary

following the Plates section. Which doesn't really tell us that much about the photographs, per se, or their production, although it does contain a veritable trove of background information on all sorts of aspects of both the history of the nineteenth century and the history of photography. For one thing, who is the Somnambulist?

"Oh, that's easy, the Somnambulist is the reader."

In that case, don't you really mean the Insomniac? But in any case, you say this book constitutes your "tribute" to Zohar and his studio. Does that mean, for example, that *you* compiled the Guide?

"Actually no. That was The Professor."

The Professor?

"Yeah, Professor De Leon."

Professor De Leon?

"Yeah, Professor M. De Leon. He was funny that way, he always used an initial instead of his first name."

Okay. Let's set the Professor aside for a moment, we'll come back to him. But "The Glass Requiem": that's the place in the book where we finally get a tranche of actual biographical information about Shimmel Zohar. How he was born in Zhidik, Lithuania, in 1822 and arrived in New York in 1857 and eventually established a photographic studio on two floors of 432 Pearl Street in a Lower East Side teeming as it was starting to be with all those Jewish immigrants streaming in from Eastern Europe.

"Yeah, I like to think of Zohar as doing for the Lower East Side of 1860s and 1870s New York what August

Sander would later do for Weimar-era Germany, attempting an exhaustive inventory of vocations and types."

And he'd been successful, but then, according to "The Glass Requiem," Zohar suddenly auctioned off the contents of his studio, or intended to but then couldn't bring himself to do so, instead locking everything up and leaving the keys with the owner of the music store downstairs, whereupon he hit the road, an itinerant photographer touring America, perhaps in search of this girl Flora, his former showgirl paramour (and had that been her, by the way, on those roller skates back there at the outset? makes you wonder, doesn't it?), planning to return to New York within a year but then simply vanishing instead, never to be heard from again. So was it the Professor who wrote "The Glass Requiem" as well?

"Oh no, that was Jeanine and me."

Right . . . okay. But how did you two first hear about Zohar? Where did you track down all that information, and how did you find the photographs?

"Well, we didn't exactly. You're reminding me of the clerk at the copyright office early on, when I sent one of the photos to be copyrighted in the name of Shimmel Zohar and they wrote me back, 'Yeah, but who are YOU?'"

Well, right, exactly: Who *are* you to Zohar, and who is Zohar to you?

"What does it matter? You're asking the sorts of questions I've spent the past twenty years avoiding, and actually kind of dreading—why are you being so insistent?"

Well, because, according to the draft I was sent, I'm

expected to be contributing an afterword under the title "The Road to Zohar," starting with a full-page frontispiece of some sort of finger-pointing sign, which, by the way, what is that?

"It's supposed to be one of the signs Zohar set up advertising his services during his itinerant year touring America, before he disappeared."

So if anything, that would make the afterword more like "The Road *from* Zohar." And where did that photo come from, anyway? Never mind. Apparently though in fact I'm supposed to be affording an account, a narrative, of how this book came into existence, presumably starting with how you, as the facilitator or whatever you want to call yourself, found your own way, your road, precisely to Zohar. In other words, some sort of plausible backstory.

"But that's just it, I don't want to get in the way. It shouldn't be about me. I suppose, too, the thing is that by nature I've always been an openly secretive person." A *what*!? "And anyway, I prefer things to be more evocative and less literal, I like to traffic in moods rather than specifics."

It was getting to be like pulling teeth. No: like *pushing* teeth. When it came to Zohar, Berkman neither wanted to have his cake nor to eat it either. Like Bartleby the Scrivener, that other cypher of nineteenth-century New York, time and again he was simply preferring not to. Or maybe, like Yahweh, he too was attempting to absent himself to make room for his creation.

Observing my growing exasperation, Berkman smiled

in sympathy and noted how his father had once said of him that one of his best qualities could also be one of his worst: his sheer stubbornness.

"How about if we just call this whole project a photographic novel?" he now suggested. "I always liked Guy Davenport's characterization of parts of his work as 'assemblages of history along with necessary fictions.' Or that line of Pynchon's about Miracle always being 'the intrusion of another world into this one.'"

I'm all for unreliable narrators, I responded—"Exactly," he interrupted, "I *am* the unreliability of narration"—to which I retorted, "*If only!*"—some narration, any narration, being all I was angling for. I recalled for him a passage in my book about our mutual friend David Wilson, the founder of the Museum of Jurassic Technology in nearby Culver City and a shape-shifter if ever there was one, his museum being one vast emporium of ontological slippage—how once, when I was gazing at a dim vitrine over to the side at the Museum that featured an array of splayed butterflies under the title "The Rose Collection of Now Extinct 19th Century French Moths,"[19] Wilson happened to amble by, and when I asked him how he'd acquired that exhibit, he recounted how one day this wonderful old lady from Pasadena (!) named Mary Rose Cannon had simply brought it in, explaining how she was downsizing her life and wondering whether the Museum might have any use for it, such a sweet woman, and they were honored to take it, although, Wilson now confided, there is a slight misnomer in the label there, since some of the moths appear

The Road to Zohar

to be Flemish. Make of that what I would, but at least there was something to make something of.

It had been a long day, we both seemed to be tiring, and we'd clearly arrived at a sort of impasse. Or rather, perhaps fallen into a Zenovian gyre: you know, Zeno's paradox, the one about how any arrow shot at a target first has to

get halfway to the target, and then halfway the remaining distance, and then half of that, and so forth ad infinitum, such that, clearly, it can never actually arrive (thereby suggesting that Saint Sebastian died not of his wounds but rather of fright)[20]—anyway, it just seemed like the harder I pushed, the deeper Berkman receded into his stubborn shell, squirting out clouds of meta–octopus ink on his way in, such that at least on that day I clearly wasn't going to attain my target. So, laughing in good-natured defeat, I suggested we call it a day and reconvene the next morning. [21]

Conjoined Twins

V

Which is what we did. Arriving the second morning, I found Berkman back in his studio, preparing his camera for a second portrait. We repaired to the darkroom, where Berkman applied the collodion to a second pristine glass pane and sensitized it in the silver nitrate bath, and then we returned to the studio, where this time he had me pose in profile, declaring "I want to see if I can immortalize that Weschler nose!"[22]

"Remember," he reminded me, "You are going to need to sit completely still for over forty seconds." Recalibrating his stopwatch, he continued, "Generally speaking, the great thing about these long exposures is how they break down the subject's resistance and you get to drill down to the real person. Okay, here we go." He removed the lens cap and dived under the cape, and as I sat there, stock still, the seconds ticking away, I couldn't help but hope that maybe the same rule would apply today to my own attempts at finally overwhelming *his* resistances.[23]

At any rate, that image, once it was presently developed, proved even more deeply and unsettlingly unmoored in time than the previous one, as if I were somehow channeling my own inner Abraham Lincoln. And in fact the effect was even more uncanny than that. Because, recalling Berkman's reference to August Sander, I now remembered how back in Berlin in the 1920s, my grandfather, the composer Ernst Toch, had agreed to pose in two photographs for the Weimar master, standing in as a representative of

Top left and bottom right: Composer [Ernst Toch], 1926, by August
Sander. 10 ¼ x 7 ½ in. Top right and bottom left: Wet-collodion glass
plates of Lawrence Weschler by Stephen Berkman, 8 x 10 in.

one of the "Artist types," and as I now dialed up those im-
ages on my cellphone, both Berkman and I were startled
by the resemblance. In fact, for a moment, we couldn't help
but wonder who had been anticipating whom, and just who
was whose ancestor.[24]

Anyway, as we resumed our seats (the wooden armchair

for me, the rickety stool for Berkman), I girded myself for yet another round of meta-wrestling, wedging myself (to change metaphors) up against the door with its broken handle and getting set to shove at it one last time. Except that suddenly the door just seemed to swing open all by itself.

"Yeah," said Berkman. "So Jeanine and I were talking last night about your insistence that I tell you the whole story about how Zohar first came into our lives, as you put it, and she basically agreed with you, that you and the readers do need to be given some sense of all that, and so, notwithstanding all my misgivings about doing so, I pulled together some materials (he reached for a manila folder) and am ready to go through the whole saga."

He paused, as if gathering up the sheer gumption to proceed.

"So, indeed," he began, "back in the late nineties, 1998 or 1999, Jeanine and I were visiting New York and staying at the Chelsea Hotel—third floor, a spare little room, group bathroom in the hallway—and one afternoon we went rummaging through the Chelsea Flea Market—I was already an avid collector of old photos and ephemera and the like—and at one stand we came upon this ancient dog-eared scrapbook, very much the sort of thing I like to collect: I love how such things, as hodgepodge as they are, come already curated, as it were, how you can see that someone has lavished all this time on creating the thing, this in an era before television and the like, so people had a lot of time. Anyway, we bought the scrapbook, for sixty dollars, and a few weeks later, back home, I picked it up

Interleave page, 10 x 12 in.,
with faint print impression made by
lithograph of Pearl Street, New York

Detail of Scrapbook Page

again and really started studying the thing, and I was
suddenly arrested by one photo in particular, a sort of
theatrical cabinet card, such things were popular back in
the mid-nineteenth century. Rufus Anson was famous for
specializing in theatrical images, and I've long particularly
enjoyed one of his daguerreotypes that depicts two charac-
ters from a play but this one in the scrapbook (here, here's
a photocopy of the spread in question and there's the photo)
was just wonderfully weird—this vagabond-like fellow with
a basket on his back, peacock feathers in his cap, with an
unusual haircut for the time, those crazy britches, against
a painted backdrop with the sort of strewn grass mat on
the floor that studios often went in for in those days, and
the fellow is in apparent colloquy with what was probably
a taxidermied crow at the end of his outstretched hand—

anyway I loved it, and I started wondering where it might have come from.

"I pulled the photo out of its mounting, sometimes they have sourcing information on the back of such cards, but no such luck, this one didn't, and I was about to give up when a blank page fell out of the scrapbook, or a seemingly blank one anyway, because when I held it up to the light, it turned out to be the kind of paper that they sometimes used for interleaves to protect steel engravings and indeed I could just make out a faint afterimage, presumably imparted by just such an engraving, and it seemed to be saying (granted, in reverse) 'Pearl Street,' and then also 'Zohar Studios.' (Here, here's a photocopy of that: the originals are already at the Museum in preparation for the show, so all I have are these photocopies, sorry.)[25] Anyway, that's what I thought it said, I wasn't sure. But I leaped to the conclusion—you know, one of those two-plus-two leaps that may or may not add up to four [26]—that the cabinet card photo had been taken at Zohar Studios, and I began to fantasize about the place, I mean, weird name and all . . .

"And the next time I was back in New York, I dropped by the Argosy Book Store on East 59th—bear with me, I realize that this whole account is becoming a bit argotic—but you know how upstairs they have those bins of old photo engravings, often arranged by neighborhood, and I knew how Pearl Street would have been in the Jewish district on the Lower East Side, so I started rifling through the bins devoted to that general area, and sure enough I found the engraving in question,

VIEW OF PEARL STREET.

Pearl Street with the 'Zohar Studios: Photographs—Views and Visages' banner off to the side, and now I could even make out the street number, which was 432—there, see it? And so I bought the engraving and rushed down to Pearl Street, hoping against hope, but of course the building had vanished, along with its address, replaced by a busy intersection, so that gambit proved useless.[27]

"But on subsequent trips Jeanine and I continued to investigate the mystery—at the library we tracked down street digests from the time, and that's how we found out about the photographer's first name, which was Shimmel, and the music store on the street level and how Zohar had occupied the top two floors. At one point we got lucky and even found his signature on the register of immigrants arriving from Bremen on the *SS Agnes* at Castle Garden where they used to process people before Ellis Island, back on May 2, 1857—here you can see it on this photocopy . . ."

Manifest of ship that brought Shimmel
Zohar to America, Port of New York, 1857

That's Zohar's actual signature!?

"Yeah, or somebody else signing his name, I suppose. But no, that's Shimmel.

"And one day we happened into Elli Buk's antiques emporium down on Spring Street in Soho, a great place that was always filled to the gills with strange scientific apparatus, arcane photographic pieces, and suchlike, that I often tried to visit on my trips back east. Buk was a really funny guy, almost made it his business not to sell you things, it was as if you had to pass this audition to see if you would be found worthy. Anyway, in the back of his store—and this was a really amazing coincidence—I came upon a battered

old trunk, and on its side was labeling with the name Shim-mel Zohar scrawled across it.

"I couldn't believe it, and I begged Buck to let me buy it, but he wasn't interested in selling. As you can imagine, I was really disappointed, but I left my name and phone number in case he changed his mind, and about six months later he called to say he was getting in a new shipment, some sort of estate sale where he'd bought up the whole place, and he was having to make room, and was I still interested in the trunk? Of course I was, so I sent him a check and he shipped the trunk here to Pasadena. When it arrived, I opened it up, but alas there was nothing inside, and frankly the thing was kind of rank and musty. So we left it outside to air out.

"And the next morning there was a baby possum inside."

A baby . . . possum?

"Yeah, it must have climbed in during the night. Our cat had a history of depositing dead baby possums on our front porch" (another great title: *Cat with a History of Depositing Dead Baby Possums*), "so this particular baby had been lucky to get away, I suppose. But it had spent the night scratching away at the bottom of the trunk, probably trying to escape, and in the process it had revealed a false bottom. And now, after we freed the possum and began further pulling away the false bottom . . ."

No! I interjected. *Really*? Unbelievable! *You found Zohar's glass plates*!

"Oh no," Berkman cut me short. "Of course not. They'd have been way too heavy, and probably have been broken

The trunk Shimmel Zohar carried with him to America.

into a million shards in transit. But I did discover a note-book, a big thick ledger sort of thing, which consisted of a handwritten diary. Unfortunately, all in Yiddish.[28]

"So what to do? My grandparents were no longer alive, so I couldn't consult them, but I remembered about my old friend Feivel—Feivel Finkel, this grizzled old fellow, a bit of a lush, I suppose, whom I'd once met at Gorky's during a klezmer trio performance. He reminded me of a character from Isaac Bashevis Singer's story *A Friend of Kafka*, because he had this intriguing old-world style of speaking and comporting himself that, granted, may have been something of an affectation. Gorky's was this bohemian dive downtown, had been there for what seemed like forever, though it had closed in the meantime.[29] I'd

originally been drawn there thanks to the name, Gorky's, which I of course associated with Maxim Gorky, who fascinated me on account of the way he had attended a Lumière Brothers projection in St. Petersburg almost the very year, 1895, that the brothers first revealed their moving picture process to the world, and he'd written the experience up in a legendary newspaper article called 'The Kingdom of Shadows.'"[30]

"Anyway, I tracked Feivel down and told him the whole story about Zohar Studios and the trunk and asked him if he could have a crack at translating the diaries, and he agreed to, and he started dropping off snatches, and the thing turned out to be Zohar's own ledger of his professional activities, with detailed descriptions of various tableaus he had meticulously staged and photographed, really bizarre sorts of things, talk about unbelievable. And it was funny, I'd tell mutual friends about some of the stuff Feivel was coming up with in his translations, and some of them warned me about how Feivel was really more of a fabulist than a translator, so at a certain point I tried to get the notebook back, but he kept coming up with all these suspicious excuses about why he couldn't bring it over. Meanwhile, though, he'd keep calling, and when I came home from teaching or whatever, there would be these long woozy messages on the answering machine. I kept the tapes, and he'd be describing yet further tableaus."

"And then one day, sometime in the early oughts, he just up and died, which I only heard about a few days later. I rushed over to his apartment to try to retrieve the notebook,

if nothing else I'd always intended eventually to donate it to the Yivo Institute, but it was too late, the place had already been cleaned out, with everything left out on the curb for the garbagemen to pick up, which they had, and that was that, I never saw the notebook again."

"Of course, I was devastated, I obsessed about the loss for months, and meanwhile I kept poring over sales and auction catalogs, hoping that some of Zohar's images might turn up, but they never did. And somewhere in there I convinced myself that still, somehow, Zohar's achievement deserved to be memorialized and honored. And so I decided to restage the tableaus myself, as Feivel had described them, like I say, as a sort of tribute to Zohar Studios."

"So yeah," he concluded, sheepishly, "technically the photos are actually mine."

"But we really don't need to make a big thing out of any of that: as I say, I myself don't want to get in the way."[31]

Woman Hand-Knitting a Condom

VI

As Berkman was coming to the end of his saga, his life partner Jeanine wandered in and, leaning against one of the cluttered tables, she now smiled at him and then over at me, with an expression that seemed to say, "There, at long last! That wasn't so hard, was it?"

"Not that it was easy," Berkman resumed, as if in response. "The project ended up taking a lot longer than I at first thought it would. It spanned four presidents, two wars, and sixteen hundred pardons[32] but I don't feel guilty in the least, I was doing exactly what I wanted to be doing, and verisimilitude takes time."

"Each of those photos," Jeanine concurred, "was like an entire short film shoot. The treatment, the script, the casting, the costumes, the makeup, the wigs, the backdrop, the lighting—sometimes it could take months of preparation for a single shot. And it was all happening here in our backyard."

"Yeah," agreed Berkman, "sometimes we'd say we had our very own Cecil B. DeMille Studio going on back here."

"Or the way John Cassavetes and Gena Rowlands would shoot their entire movies in their own house," Jeanine elaborated.

Berkman had earlier conveyed to me his conviction that while cinema grew out of theater, photography—or anyway this kind of photography—aspired more to the condition, the concision, the concentration, of poetry. Perhaps, but in their staging, the Berkmans now both seemed to be

suggesting, these photographs had been more like cinema. Albeit single-shot cinema, with a take that (when it finally took) lasted only forty seconds. Berkman liked to say that he aspired to an "artificial naturalism," a term which he suggested implied a doff to the Lumière Brothers, who first called their moving pictures "*actualités*," which is to say, realities. ("Making the real *real*," Eudora Welty used to say, "is art's responsibility.")

"I remember how growing up in the Bay Area," Berkman commented, "I used to visit Kepler's Bookstore and spend afternoons just leafing through Diane Arbus' great *Monograph* book, I couldn't afford to buy it, but I really admired the kind of thing she'd been doing. Her people, her subjects, their gaze really pierced you because she had pierced them. Some people say she just got lucky. But no, there are artists like her who have a personal vision so powerful that they can go out into the world and locate instances of it all over the place, almost like they are projecting their inner vision onto the world outside. But I'm not like that. I hardly ever take pictures in the world outside: I went to Nebraska once, and I took one picture. Rather I go out into the world in search of instances out there of the sort of thing I am going for, but then I have to reel them back into this space, *this* inner space.

"For example, the people in these Zohar re-creations of mine. Hardly any of them were my friends, Ricky Jay was just about the only one who is recognizably well known. No, I'd have a vision of the sort of thing I needed, but then I'd spend weeks looking for people who might fit the vision. 'The

three Q's' is how I used to describe my aesthetic: Quixotic, Quotidian, and Quasimodo."

Quasimodo?

"Well, yeah. The opposite of conventionally attractive. Kind of exiled, set-off, suspect . . ."

Outsiders? The Community of the Refused?

"Yeah, and when I'd see people like that—the thing is I'm basically a shy person, it was always really hard for me to just go up to them and ask if they would be willing to sit for me, to take part in these daylong stagings. But maybe that's where my sideburns came in useful, they gave me a sort of authority, I suppose, I mean they conveyed seriousness . . ."

Seriousness?

"Well, commitment anyway, that this wasn't just some sort of lark, that I was seriously committed to the project.

"It didn't always work. I mean, one time over at Skylight Books, I came upon the single best face I ever saw, and I went up to the guy—we got into this really amazing conversation, he was very profound, he had this Byzantine mind, was kind of a mystic and he zeroed all his energy in on me, we went at it for a long time, and eventually I asked him if he'd be willing to sit for one of my pictures, and he said he couldn't possibly, and I asked whyever not, and he said it was because he was *invisible*! I tried to assure him that that might not prove an insurmountable obstacle, but he still demurred."

I laughed, and laughing, found myself asking Berkman about the humor in the images. Had it been Zohar himself who was so humorous, so witty, or was that him, Berkman,

his specific take on the descriptions of the tableaus that Zohar had provided in his diary? For example, who came up with the titles, the downtrodden banana and the like? Were those his or Zohar's?

"That's a good question," Berkman said. "I'll have to think about that."[33]

I sensed we might be about to slide back into the vertiginous sublime all over again, so I decided to steer the conversation slightly elsewhere. Because it wasn't as if the commentaries were of much use in this regard: most didn't even seem to address the specifics of the images themselves at all. On the other hand, taken together, they provided an astonishing breadth of insights into the nineteenth century as such.[34]

"As I say," Berkman responded, "all along this project was intended to be a tribute both to Zohar Studios and to the historical imagination.[35] Early on, I realized I was going to want to model its presentation, to a certain degree (if only formally, I mean obviously I'm not claiming any equivalence in terms of achievement), on Nabokov's *Pale Fire*, a novel I've always loved, that business of a division between an instigating artwork—John Slade's poem—and the ensuing exegesis (Charles Kinbote's commentary), which ends up taking up the bulk of the volume."[36]

I saw what he meant though, about his consuming obsession with the nineteenth century ("I sometimes feel more connected to people who are no longer here," he'd once told me, "than to those that are")—the Somnambulist's Guide

(whether or not correctly titled) displayed a truly astonishing command of the subject.

"But again," Berkman corrected me, "that wasn't me. I'd have loved to provide such a commentary, but we were running out of time, there was no way I was going to be able to do so, so I contacted the Professor."

Oh right: The Professor. I asked him to remind me about the Professor.

"Professor M. De Leon. I first met the Professor at a collectors show, the Ephemera Society annual fair. It was quite a few years back. I was talking to my friend Carl Mautz, who publishes books on photographic history. Carl is known for ferreting out unusual characters like Ken Appollo, a photographic historian who wrote *Mad Wanderings: Street Life in the Machine Age.* Anyway, Mautz introduced me to the Professor, who happened to be there, looking for new material for his own collection. He referred to himself as an itinerant scholar of nineteenth-century cultural history, and he was the conservator of a distinguished private collection. He wasn't at liberty to say whose collection, but they seemed to have deep pockets. He traveled a lot for work. He also served as a consultant for other collectors and as an independent curator and historian. He was regularly called on by museums to research new pieces that they were considering acquiring, and he also provided detailed information that they then used in their catalogs.

"Anyway, we became good friends, or at least fine acquaintances. I'd been keeping him apprised of developments following my Zohar discovery. After Feivel died suddenly,

I'd been left to pick up the pieces of the project, and as the years passed it was just proving too much. My life was moving toward entropy, my fountain pen was leaking, my pocket watch was running late, and all the doorknobs in my studio were broken. I was clearly in over my head just with restaging the photographs, I wasn't sure I'd ever be able to finish them,[37] so a few years back I contacted De Leon and asked whether he might be willing to take on the commentary, and he was game.

"Nor was he bothered by the fragmentary nature of what we knew about Zohar because he understood that most nineteenth-century work is incomplete. He didn't seem too concerned with the ambiguity of the information, because often with nineteenth-century photographers there is not much to go on anyway. Using the scant information I could provide as a point of departure, he added in all of the historical context and characters. Ultimately, he saw Zohar as a minor part of the story. To him, the photography took precedence. Most people like to focus on the artist, but he wanted to focus on the art."

Or anyway, on the century as a whole, I suggested. In any case, he sounded like a fascinating fellow. I asked Berkman if there were any chance I could call on him.

"How I wish!" he replied, pausing. "But I'm afraid that won't be possible. He died just a few months ago. So sad. He'd finished his contribution to the book just a few months before that, but yeah, now the volume will be serving as a kind of tribute to both Zohar and De Leon. Too bad though: you really would have liked him."

I was sure I would have. I liked both his writing and his turn of mind.[38] I looked at my watch and was surprised to see how time had flown. Speaking of which, I had a plane to catch. I thanked both of the Berkmans for their kind hospitality and said I had to be on my way.

As Stephen now walked me back through the alley and the clutter of his DeMille Studio backyard, he suddenly declared, "Every artist is their own sovereign state, with their own laws, by-laws, and occasional uprisings."

Who said that? I asked.

"I did."

We forged on through the clapboard gate and past the two trucks in the driveway toward my own rental car. "Have you ever noticed," he went on, "how with Bob Dylan, it's the refrains that anchor the whole piece? As long as he keeps returning to the refrains, the rest of the song can range pretty much anywhere, and does. That's kind of how I think of Zohar Studios: focusing on Shimmel's achievement has allowed me to range all over the nineteenth century and for that matter the entire historical imagination. Although Dylan may be the wrong musical analogy: I sometimes find myself thinking of this whole project, rather, as Chopin played on a kazoo."

We'd reached my car, I turned to congratulate him, whichever the analogy, on the completion of his work. I told him it must be a great feeling, and he smiled, correcting me. "It's been a great *privilege*," he said. "It's not every day you get the opportunity to make history."

Making History: another great alternative title.

Portrait of a Blind Mohel

VII
ON THE SEVENTH DAY HE RESTED

So anyway, that's all I've got—and yes, I realize that it doesn't entirely hang together. Sometimes things can get like that and what are you going to do.

Oh, except for this! On my way out of Pasadena and back to LAX, I dropped by the Museum of Jurassic Technology in Culver City (as I say, don't even get me started) to visit with the place's founder, David Wilson. (When I told him I'd been in town on an assignment from San Francisco's Contemporary Jewish Museum to compose some sort of contextualizing afterword for the volume accompanying their upcoming show of Stephen Berkman's Zohar project, he responded, "Oh, thank god.") Anyway, as some of you may know, the MJT includes within its precincts a Napoleonic Library (again, long story, not now), upon whose pell-mell shelves I happened to locate a copy of Gershom Scholem's magisterial *Major Trends in Jewish Mysticism*, the very volume I remembered so fondly from my own college days. I asked David if I could borrow the volume for my plane ride back to New York, and he graciously agreed (as long as I sent it back, which in the meantime I have).

Which explains how a few hours later, utterly absorbed in perusing the book while cruising somewhere high over the wide flat heartland of America, I came upon Scholem's account of his insanely erudite philological investigations into the actual authorship of the volume that is perhaps Kabbalah's foundational document, the one Luria would

later train his penetrating interpretive energies toward in the fifteenth century, the *Sefer Ha-Zohar*, "the Book of Splendor," commonly known as the Zohar. Though the book purports to present itself as the product of the eminent second-century Mishnah teacher Simeon ben Yohai's thirteen years of intensive Torah study while hiding out from the Romans after the destruction of the Temple (holed up deep inside a Palestinian cave), Scholem, across over fifty pages of tiny print (based on his own burrowings into archives scattered all around the world), unfurls his definitive proof that the book was in fact the work of an obscure late thirteenth-century Spanish rabbi out of the Castilian village of Guadalajara by the name of—wait for it—Moses de Leon.

And if, like me, you had recently found yourself in the company of Rebs Stephen Berkman and Jeanine Tangen, you too might recognize the neighborhood of Scholem's loopily recondite argument, on behalf of this proof, as in this passage, based on the contemporaneous account of a traveler named Isaac ben Samuel of Acre who subsequently recorded how he was told by a rich merchant named Joseph de Avila that following the death of Moses de Leon, he (Joseph) had offered to marry his son to De Leon's daughter in exchange for the original second-century manuscript that De Leon had claimed as the source of his own writings, "but that both the widow of the deceased and his daughter had denied the existence of such an original. According to them, Moses de Leon had written the Zohar all by himself, and, to his wife's question as to why he did not claim authorship of the work, had replied, 'If I told people that

I am the author, they would pay no attention nor spend a farthing on the book, for they would say that these are but the workings of my own imagination.'"

So, go figure.[39]

A TROVE OF ZOHARS

ENDNOTES
{a digressive delirium}

Latent Memory

I

1 {pg 11} Which is to say, she's not the Gravity Goldberg whose teaching blogsite floats to the top of the roster when you Google the name: she's the *other* one. *There are two of them!* Neither of which, incidentally, wins the prize for my single all-time favorite happenstance name, which would instead have to go to a producer at CBC radio, who introduced herself as Diane Eros, the name her parents *gave* her (!). But I digress.

2 {pg 11} "I don't know where it came flying from, but suddenly, in the midst of everything, I felt on my forehead a wet mud-patch. I looked round. Who could it be, and who had thrown it? Saw nobody. And at once removed the mud-patch with my hand, and lo, a coin."

Thus did Pinchas Kahanovich, more commonly known as Der Nistor, one of the very greatest of the fabulists of the Soviet Yiddish Renaissance (born 1884 in Berditchev in the Ukraine, died in the gulag in 1950, a victim of that year's Great Soviet Purge of Yiddish literature), launch out into his remarkable tale, "From My Estates" (translated by Joseph Leftwich and included in his 1963 collection, *Yisroel: The First Jewish Omnibus*, pp. 495ff).

Der Nistor

And indeed, it can get to be like that, sometimes, exactly like that.

The Baroness of Babylon Boulevard

Felice Bauer & Franz Kafka

3 {pg 12} So much is confounding about this particular image, for starters, as suggested, whether the Baroness is even a woman. Beyond that, we feel as if we've already encountered her somewhere before, and then things begin to gel, for in fact she seems a perfect midway amalgam of the two figures in the famous portrait of Franz Kafka and his sorry epistolary paramour Felice Bauer (of the ill-starred engagement).

4 {pg 13} An image which in turn put me in mind of one of the cardinal distinctions imparted to me on one of my first writing assignments, back in the late seventies, by that eminent Hollywood rebbe, Melvin Brooks, whose directorial

labors on his at-that-time next film, *High Anxiety,* the editors at the *Village Voice* had dispatched me to chronicle. "A man is walking down the street," the Good Rebbe, pulling me aside at one point, endeavored to explain, "and he slips on a banana peel, goes flying head over heels through the air past a milling group of utility repairmen and right into the manhole they've just recently uncovered—crash, clatter, screaming, moaning, groaning—the ambulance is called and presently the poor fellow gets reeled out, every limb in a sling, his head all bandaged, groaning, moaning, and he's hauled away. Now, *that's* comedy! On the other hand, if *I* get a splinter on my pinkie: *that's* tragedy."

Rebbe Melvin Brooks

Which in turn also reminds me, come to think of it, of an incident I once encountered by way of a news bulletin—true story—about a guy washing his hands in the bathroom cubicle of one of those superfast French TGV trains as it raced somewhere between Paris and Marseilles, when his wedding ring slipped off his finger and caromed into the open toilet basin below and then down the drain. Undaunted, the gentlemen rolled up his sleeve and reached deep inside, grabbing the ring but getting his arm stuck so deep in the process that no matter how hard he tried, he couldn't wedge it out. He tried to kick the door to summon help, but he couldn't quite reach it.

People on the other side of the door meanwhile began angrily pounding, demanding to be granted their turn. Eventually the conductor was called, at length he managed to unlock the door, and the whole sordid situation was revealed. Other conductors arrived, everyone trying to free the fellow from the trap. Eventually the hurtling train had to slow down and pull to a complete stop at a little village station so that the *pompiers* could be called to the scene. While TGVs all over Europe began grinding to a halt in cascading response to the ensuing blockage, the pompiers ended up summoning the village blacksmith, who sawed the entire unit out of its mooring and transported the conjoined fellow and toilet out onto the platform, where, in full view of everyone on the train and half the village's gawking population, a good half hour of further ministrations proved necessary until they finally managed to free the sorry fellow from his misery. And the thing of it was, Jerry Lewis—I kid you not—happened to be on the train in question and got to watch it all, and was subsequently quoted as saying that this might have been the happiest moment of his life.

Detail from
Shtetl Shtick

The Sixth Day by
Charles Bragg

5 {pg 15} Compare Zohar's conception, *Shtetl Shtick*, with the more recent artist Charles Bragg's inspired etching, *The Sixth Day*.

"God invented Man," in that transcendent formulation variously attributed over the years to Mark Twain, Voltaire, Frank Wedekind, and countless others, "and Man returned the favor."

As for Eve, lounging there still only half-formed on the Great Puppeteer's worktable in Bragg's conception, that of course is a whole other story. But one that has long been misconstrued, or so argue a daisy chain of recent contemporary biologists (a doff of the cap to Walter Murch for alerting me to this particular trill). As Richard O. Prum, professor of ornithology and Head Curator of Vertebrate Zoology at the Yale Peabody Museum, relates in his *Evolution of Beauty* (2017), the whole notion of God

having fashioned Eve out of Adam's rib has never made much sense (early on, kvetching Talmudists were pointing out that men and women still had the same number of ribs, so what was up with that?), and the reason it doesn't is because He didn't. It's all been a huge misunderstanding.

(*Trigger warning as to what follows: any dallying children or other such childlike innocents are emphatically encouraged to revert immediately to the main text.*)

Prum notes that human males are among the relatively few mammals, and the only ones among the primates, that somewhere along the way lost their baculum, their penis bone. At which point the birdman of Yale defers to Swarthmore developmental biologist Scott Gilbert and UCLA biblical scholar Ziony Zevit, and their strenuously ignored 2001 paper "Congenital Human Baculum Deficiency: The Generative Bone of Genesis 2:21–23," in which they point out that the ancient Hebrew noun *tzela*, which ordinarily gets translated as "rib," could just as easily be rendered as a whole series of words "used to indicate a structural support beam," continuing, self-evidently, to note how "'Structural support beam' is a very succinct description of the baculum." There is something eminently more narratively satisfying (or, alternatively, distinctly unsettling, depending on one's point of view) about God having plucked Adam of his baculum rather than his rib as the basis for his creation of Womankind. But to clinch their case, professors Gilbert and Zevit further note how:

Genesis 2:21 contains another etiological detail: "The Lord God closed up the flesh." This detail

would explain the peculiar visible sign on the penis and scrotum of human males—the raphe. In human penis and scrotum, the edges of the urogenital folds come together over the unrogenital sinus (uretral groove) to form a seam, the raphe . . . The origin of this seam on the external gentalia was "explained by the story of the closing of Adam's flesh."

Which in turn, I suppose, brings us back, in Zoharian terms, to that prim lady knitting her condom.

Madeleine Gonzalez, Petrus Gonsalvus 1580
daughter of Petrus, age twelve.

6 {pg 16} As suggested, Shimmel Zohar was by no means the first artist in history to have evinced a fascination with the hairy—consider in this regard the countless often anonymously painted renderings of Petrus Gonsalvus (born Pedro Gonzalez on the Canary Islands in 1537),

whose genetic hypertrichosis rendered him an object of wonder, much prized as a guest in royal courts throughout Europe, starting with that of the French king, Henry II (Petrus's marriage there to the fair maiden Lady Catherine is thought to have inspired the 1740 novel *La Belle et la Bête* by Gabrielle-Suzanne Barbot de Villeneuve), and extending to his several similarly graced daughters, especially Madeleine—and for that matter, as well, the following century's Magdalena Ventura, the bearded lady

at the Court of Naples, who became the subject of an extraordinary 1631 painting by the Spanish tenebrist master Jusepe de Ribera (for more on *that* painting and *its* strange progeny, see the piece on "Bearded Ladies Breastfeeding" at my website, www.lawrenceweschler.com). But there can be no doubt that when it came to this sort of thing, the force was still exceptionally strong, several centuries later and well across the sea, in the work and focus of Shimmel Zohar:

A Pervasive (Perversive?) Fascination

Lazy Susan

Forget Me Knot

Merkin Merchant

The Princess of Prussia

And for that matter, remained strong in the work of Joseph Mitchell, another passionate chronicler of the demimondes of the hirsute in Lower Manhattan a few genera-



tions after Shimmel (oh how the one would have savored the other, if only they could have met!). Recall in particular (as Berkman himself is often given to doing, *word for word*) the opening of Mitchell's August 3, 1940, *New Yorker* profile of Lady Olga:

P R O F I L E S ⁑

LADY OLGA

JANE BARNELL occasionally considers herself an outcast and feels that there is something vaguely shameful about the way she makes a living. When she is in this mood, she takes no pride in the fact that she has had a longer career as a sideshow performer than any other American woman and wishes she had never left the drudgery of her grandmother's cotton farm in North Carolina. Miss Barnell is a bearded lady. This season her thick, curly beard measures thirteen and a half inches, which is about as long as it ever gets. When she was young and more entranced by life under canvas, she wore it differently every year; in those days there was a variety of styles in beards—she remembers the Icicle, the Indian Fighter, the Whisk Broom, and the Billy Goat—and at the beginning of a season she would ask the circus barber to trim hers in the style most popular at the moment. Since it became gray, she has worn it in the untrimmed, House of David fashion.

Joseph Mitchell, Profile of Jane Barnell, the Bearded Lady, *The New Yorker*, August 3, 1940

7 {pg 16} One is perhaps put in mind of that great Russian lepidopterist V. V. Nabokov's splendid comment to the effect that the True Master blends the precision of

The Lepidopterist of Montreux

the poet with the imagination of the scientist. The same Nabokov, in addition something of a scribble-dabbler, who once surprised his Italian publisher Roberto Calasso by telling him that he'd never been to Venice. "Good Lord, why ever not?" asked Calasso, abashed, to which Nabokov replied, self-evidently, "No butterflies."

Speaking of which, there is this delicious passage from the beginning of Eowyn Ivey's recent *New York Times* review of Leone Ross's new novel, *Popisho*:

> In the writers' world, I've encountered the notion that ideas are like butterflies, landing softly on this shoulder or that brow and, if the writer is not quick enough, flitting off to find another, more receptive mind. The idea lends a sense of urgency to the writing process—quick, write that novel before someone else does! Or maybe it provides the hope that inspiration is plentiful and free and waiting to be plucked out of the air.

I'm not convinced. Sure, on a basic level, every story has been told before and will be told again, but the novels I've found the most urgent and fascinating are so specific to their authors that they couldn't have been written by anyone else.

8 {pg 17} And what kind of name is *Shimmel* anyway? Sounds like *schlemiel* and, by way of schlemiel, seems to summon forth the entire Yiddish lexicon for pathetic losers—the schlimazls, the shmendriks, the klutzes and dumpkopfs and nebachs (origin of the Yinglish nebbishes) and yutzes, the doufusses and schoneggeges, and on and on, in all their sublime glory.

Actually, no, though: it turns out that "Shimmel" is simply the diminutive of "Shimon," an entirely unobjectionable appellation. But still, the first time I heard it, the name immediately reminded me of a conversation I had with Cheryl, a delightful Italian-American girlfriend I had for a few years just out of college (I taught her guilt, as we used to say, and she taught me shame), and how one time I was trying to explain to her the ever so subtle distinction between a *schlemiel* and a *shlimazl* (how if you happen to be at a party and you see one fellow spill the onion dip all over another, the one who does the spilling is the schlemiel and the one spilled upon is the schlimazl), which led into a wider celebration of all the exquisite nuances that Yiddish affords for all the different types of loserhood, whereupon she interrupted me to inquire, self-evidentially, "Oh, so is that like Eskimos and snow?"

II

9 {pg 20} And if only I could refer you to a photograph of said gentleman so you'd be able to credit even

Painting of the photographer
Stephen Berkman by Jeremy Lipking

half of my claims re those bouffant burns! But alas, in an entire book given over to the photographs of Shimmel Zohar, the coffee-table tome features not a single snap of the master's recent rediscoverer—and meanwhile only one sole painting in the entire volume (on the book jacket's back flap), that one being a portrait of the man in question as a younger version of himself (much idealized, believe me), a dandy lost in time.

Meanwhile, several times when I tried to deploy my own iPhone camera in order to prize a likeness, Berkman went all shy and maiden-coy and indicated a decided preference that I not do so. Thus, for the time being anyway, we may just have to settle for that painting, though trust me, I will continue to endeavor to sneak in some alternative in the pages that follow.

10 {pg 21} Granted, as the sage poster (see right, above) stipulates, to which Berkman has been known to add,

"Technically, it's not hoarding if you can see the floor."

III

11 {pg 33} One is likewise reminded of one of the earliest mega-viral videos, from way back in January 2009 (having been viewed in the meantime over 140 million

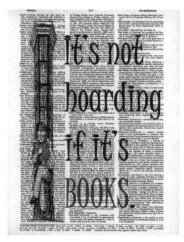

times, as of 2021), the legendary "David after Dentist" (https://www.youtube.com/watch?v=txqiwrbYGrs), in which the eponymous youngster, missing a front tooth and buckled into the raised back kidseat of his father's car, slurringly inquires whether he has stitches (yes, his father assures him, he does), before going on to declare that he feels . . . ah . . . he can't quite come up with the word but then woozily rolling his head about the thin stalk of his neck, inquires, *"Is this real life?"* Staring numbly at the hands in front of his face with their two outthrust digits, he declares, self-evidently, "I have two fingers," before correcting himself, "I have *four* fingers," before further establishing, "I can't see *anything,*" at which point he stretches up from out of his seat and issues forth a manic bellowing howl before collapsing back into his constraints, and then, looking up at his father accusingly, declares, *"You* have four eyes!" Groggily he goes on to insist, "I don't *feel* tired," but quickly clarifies, "I feel *funny,*" whereupon he ponders, in further

David after Dentist

exasperation, *"Why is this happening to me?"* and then asks, quite sensibly, "Is this going to last *forever?"*

Altogether a first-rate trill of metaphysical speculation, notwithstanding its precocity.

12 {pg 34} Early on in my career at the *New Yorker*, Mr. Shawn, the magazine's legendary editor, sent me a little note, in his distinctive feathery handwriting, inquiring as to whether I might like trying my hand at contributing fiction. I replied by way of a quickly drafted typed memo (we typed in those days, with keystrokes, onto paper) on why I couldn't possibly, and a few days later, that memo appeared, pretty much verbatim, anonymously (as all such contributions were in those days), as the lead item in that week's Notes and Comments section, under the rubric "A young reporter friend writes":

> Friends of mine sometimes ask me why I don't try my hand at writing a novel. They know that novels are just about all I read, or, at any rate, all I ever talk about, and they wonder why I don't try writing one myself.
>
> Fiction, they reason, should not be so difficult

to compose if one already knows how to write non-fiction. It seems to me they ought to be right in that, and yet I can't imagine ever being able to write fiction. This complete absence of even the fantasy of my writing fiction used to trouble me. Or not trouble me, exactly—I used to wonder at it. But I gradually came to see it as one aspect of the constellation of capacities which make it possible for me to write nonfiction. Or, rather, the other way around: the part of my sensibility which I demonstrate in nonfiction makes fiction an impossible mode for me.

That's because for me the world is already filled to bursting with interconnections, interrelationships, consequences, and consequences of consequences. The world as it is is overdetermined: the web of all those interrelationships is dense to the point of saturation. That's what my reporting becomes about: taking any single knot and worrying out the threads, tracing the interconnections, following the mesh through into the wider, outlying mesh, establishing the proper analogies, ferreting out the false strands. If I were somehow to be forced to write a fiction about, say, a make-believe Caribbean island, I wouldn't know where to put it, because the Caribbean as it is is already full to bursting—there's no room in it for any fictional islands. Dropping one in there would provoke a tidal wave, and all other places would be swept away. I wouldn't be able to invent a fictional New York housewife, because the

city as it is is already overcrowded—there are no apartments available, there is no more room in the phone book. (If, by contrast, I were reporting on the life of an actual housewife, all the threads that make up her place in the city would become my subject, and I'd have no end of inspiration, no lack of room. Indeed, room—her specific space, the way the world makes room for her—would be my theme.)

It all reminds me of an exquisite notion advanced long ago by the Cabalists, the Jewish mystics, and particularly by those who subscribed to the teachings of Isaac Luria, the great, great visionary who was active in Palestine in the mid-sixteenth century. The Lurianic Cabalists were vexed by the question of how God could have created anything, since He was already everywhere and hence there could have been no room anywhere for His creation. In order to approach this mystery, they conceived the notion of *Tsimtsum*, which means a sort of holding-in of breath. Luria suggested that at the moment of creation God, in effect, breathed in—He absented Himself; or, rather, He hid Himself; or, rather, He entered into Himself—so as to make room for His cre-

Tsimtsum as recently portrayed on a unisex sweatshirt

ation This *Tsimtsum* has extraordinary implications in Lurianic and post-Lurianic teaching. In a certain sense, the *Tsimtsum* helps account for the distance we feel from God in this fallen world {...}

But I digress. For me, the point here is that the creativity of the fiction writer has always seemed to partake of the mysteries of the First Creation (I realize that this is an oft-broached analogy)—the novelist as creator, his characters as his creatures. (See, for example, Robert Coover's *The Universal Baseball Association, Inc., J. Henry Waugh, Prop*, in which, for J. Henry Waugh, read *Jahweh*.) The fictionalist has to be capable of *Tsimtsum*, of breathing in, of allowing—paradoxically, of creating—an empty space in the world, an empty time in which his characters will be able to play out their fates. This is, I suppose, the active form of the "suspension of disbelief." For some reason, I positively relish suspending my disbelief as long as someone else is casting the bridge over the abyss; I haven't a clue as to how to fashion, let alone cast, such a bridge myself.

13 {pg 34} A vast amount of speculation in the Kabbalistic tradition before Luria had been given over to a meticulous charting of the originary alignment of and relationships between those ten vessels, the *Sefirot*, from before the Fall, sometimes conceived, in a blending of metaphors, as the primordial Adam or even the Tree of Life itself. Hence the famous woodcut of the Kabbalist lost in thought

Portae Lucis by Joseph Gikatilla, 1516

gracing the cover of Joseph Gikatilla's "Portae Lucis" (yet another metaphor: "The Doors of Light"), first published in Augsburg, Germany, in 1516. The Sefirot constituted the ten emanations, the ten creative forces that mediate between the infinite, inconceivable God, the *En Sof* (the Without-End, the Boundless), and the realms of material creation: the left column, the masculine side as it were, consisting of *Binah* (Understanding), *Din* (Justice), and *Hod* (Glory); with the right side, the more feminine side, consisting in *Hokhmah* (Wisdom), *Hesed* (Mercy), and *Netzah* (Eternity). The middle column, the spine or the trunk, which united the two outlying files, in turn consisted of *Keter* (the Divine Crown), *Tiferet* (Beauty), *Yesod* (Foundation), and at the very bottom *Shekhinah* (the Divine Presence in the World). Indeed, further mixing metaphors, the precise hydraulics between the various stacked vessels was the subject of

yet further fevered speculation, with each intervening conduit understood to be serving a very specific function across a system of compounding complexity, regarding which this account barely begins to scratch the surface.

Luria, for his part, working in the wake of the traumatic expulsion of the Jews from Spain during the immediately prior generation, took this relatively static configuration and reimagined it in far more dynamic terms, starting out with that concept of the *Tsimtsum*, by way of which the *En Sof* absented himself from the world in order to make room for Creation, at a certain point during which he directed the overpowering Light of his being into the grid of Sefirot . . .

14 {pg 35} . . . but, as discussed, something went disastrously wrong, resulting in the shattering of the vessels, the Shevirat Ha-Kelim, represented perhaps most uncannily in our own time, 475 years after that earlier rendering of the old medieval Kabbalist before his Portal of Light, through the vision of another German grand master, in this case Anselm Kiefer's harrowing 1990 *Bruch der Gefäße* ("The Breaking of the Vessels"), with its own wrenching prospective premonition (or alternatively, subliminal

Bruch der Gefäße by Anselm Kiefer

natively, subliminal retrospective reverberation) of the
Nazis' dread Kristallnacht of November 1938, in some ways
the first real intimation of the then-onrushing Holocaust.

Luria's conception was essentially a reworking of ancient
Gnostic and specifically Manichean doctrines, with the Ca-
tastrophe sending shattered shards and droplets ("sparks")
of light crashing into the abyss, which is to say the lifeworld
of Creation, our world, the world of human pain—and yet in
an inspired twist, Luria's God was now depicted as Himself
somehow also wracked by the outcome, human pain being
in a certain sense his own pain as well—at any rate He could
no longer repair the damage by Himself.

All of this constitutes a novel take on the age-old di-
lemma of theodicy: the problem of evil, or more precisely
of how an omniscient, all-powerful and good God could
ever have allowed evil into the world. Some have suggested
that maybe God simply can't be all three (He might thus
be all-powerful and good, but for some reason doesn't
know what's going on; or He might be both all-knowing
and all-powerful, just not good). Other accounts, for
example the standard Christian resolution of the dilemma,
have had recourse to the notion of free will (God allows
evil in the world in the context of lavishing free will upon
his human subjects and allowing them to come to their
own terms with its temptations)—but what if a once
all-powerful and all-knowing and good God has himself
been rendered wounded and blinkered by the Fall and
hence unable to repair things by himself? This state of
affairs would in turn necessitate the centrality of man's

distinct (almost co-equal) role in *Tikkun*, the repair of the world.

The preeminent contemporary scholar of the history of Jewish mysticism, Gershom Scholem, placed the Lurianic moment in fascinating context, both retrospectively and prospectively. He sketched out how, following the catastrophic failures of a sequence of Jewish revolts against the Romans between 70 and 135 CE and the consequent expulsion of vast numbers of Jews from Palestine, over the ensuing centuries the scattered Jews in their Diaspora contrived two basic ways of reconstituting their Temple in exile: first, the Talmudic, or legalistic, tradition, by way of which the Jews defined their farflung solidarity through adherence to a strict regime of *common* rabbinically interpreted and enforced laws (for example, with regard to keeping kosher households, or the group study of common texts in Yeshivahs, and the like)—but also, secondly, by way of a parallel Kabbalistic or mystical tradition, whereby *individual* Jews through myriad intense devotional practices attempted to constitute their very selves as the Temple incarnate, even if in exile. For almost a millennium and a half, according to Scholem, the two traditions ran in a fruitful, parallel, dialectical relation, but in the wake of the Lurianic revelations, the Kabbalistic movement began to strain against the strictures of the broader Talmudic authorities, in particular by fomenting a sudden upsurge in previously relatively quiescent messianic expectations (after all, the imminent appearance of such a Messiah could be seen as the climactic confirmation

The false Messiah
Shabtai Tzvi

of a human-launched campaign of *Tikkun*), culminating a century later, with the astonishing appearance of Sabbatai Sevi (alternatively denominated "Shabtai Tzvi," or with any number of alternative spellings), a wildly charismatic (apparently Tourettic) Smyrna-born Kabbalist who, at the approach of the year 1666 (a date freighted with apocalyptic millennial expectations on the part of all sorts of denominations throughout Europe) declared himself the Jewish Messiah, quickly gathering up the fervent devotion of hundreds of thousands of beleaguered Jews throughout the Continent, to the horror of most of their rabbinical authorities (especially so because he declared that what with his arrival, Jews no longer needed to follow their strictures, no longer for example needed to keep kosher). Sevi proceeded to march on Constantinople, where he predicted he would confirm his messianic vocation by convincing the Ottoman Sultan to give Palestine back to the world's Jews (the farflung anticipatory frenzy reaching a fever pitch)—but in the event, the would-be Messiah was arrested at the city's gates and thrown into jail, only to emerge several months later, *having converted to Islam*!

The shock of this development of course shattered the movement: many reverted shamefacedly to conventional orthodoxy; others lost their faith altogether; but surpris-

ingly, not a few retained their conviction that Sevi had in fact *been* the Messiah, reasoning that he had selflessly descended into the deepest darkest abyss of apostasy so as to gather up the remaining shards and droplets of light scattered about down there, and that he would soon be returning triumphant (a conviction not altogether that different, when you think about it, from how the earliest Christians responded to what was after all the *actual execution* of their leader). Scholem, for his part, compiled a thousand-page chronicle of the entire affair, arguably his magnum opus.

Generations passed, many of these believers grew increasingly antinomian and politically radical, including a sect of Frankists (followers of Jacob Frank, a subsequent Polish Jewish messianic claimant), a yet more fervently transgressive group who arguably helped seed the ground for the French Revolution in 1789. And many of those, or anyway their heirs, found their way beyond that into the rationalist assimilationist movements of the nineteenth century (people who, for example, still considered themselves somehow Jewish even though they no longer felt the need to keep kosher). Which may help explain, or so Scholem suggests, why one keeps finding thoroughly assimilated, in some cases almost completely deracinated Jews—Marx, Freud, Kafka, even Einstein to an extent—in turn fashioning elaborate secularized versions of essentially Kabbalistic notions of the Fall and Redemption.

Not to mention the great artist-writer Bruno Schulz,

Bruno Schulz

a favorite of Berkman's, who was killed in 1942 by a passing Gestapo officer while trudging home, a loaf of bread tucked under his arm, in his provincial hometown of Drohobych—immediate victim, it seems, of a petty rivalry between two Nazi officers, one of whom was getting back at the other who had been protecting Schulz, having recruited him to paint scenes of fairy tales across the walls of his five-year-old son's bedroom. As a result, the magnum opus Schulz had been laboring over, a novel called *The Messiah*, was also lost, like so many of Schulz's fellow citizens, in the Holocaust. Though Berkman prefers to think that, as with that lost manuscript's namesake, we all just find ourselves pining for the text's reappearance. The specter of Schulz's lost novel has in any case exerted a powerful thrall over subsequent literature, showing up almost simultaneously in 1986–87 as a central motive element in both Cynthia Ozick's *The Messiah of Stockholm* and David Grossman's *See Under Love*.

As for the boy's bedroom walls with their fairy tale renderings, also long thought lost, they were in fact rediscovered in 2009, launching a fierce polemic as to where they should be preserved—in Poland (Drohobych had been part of Poland before the war, and Schulz is considered one of the greatest stylists of the Polish language) or in the Ukraine (where

Drohobych was now situated and whose greatest laureate Schulz had long been considered)—a polemic settled by default when a group of experts from Yad Vashem, Israel's Holocaust museum, swooped in and pried the images off the walls, largely wrecking them in the process, and spirited the splintered remains back to Israel (in a latter day echo, some couldn't help but note, of the Kabbalistic Shattering of the Vessels).

Meanwhile, in the wake of the desolation occasioned by the False Messiah's apostasy, another strand of the Kabbalistic tradition had reformed as the Hassidic movement, built around its own series of charismatic leaders with their own intensified notions of man's relation to the divine, often transmitting their doctrines by way of vividly rendered tales and parables. As, for example, in one such story conveyed by Elie Wiesel in his 1978 collection *One Generation After*:

> Having concluded that human suffering was beyond endurance, a certain Rebbe went up to heaven and knocked at the Messiah's gate. "Why are you taking so long?" he asked him. "Don't you know mankind is expecting you?"
>
> "It's not me they are expecting," answered the Messiah. "Some are waiting for good health and riches. Others for serenity and knowledge. Or peace in the home and happiness. No, it's not me they are awaiting."
>
> At this point, they say, the Rebbe lost patience and cried: "So be it! If you have but one face, may it

remain in shadow! If you cannot help men, all men, resolve their problems, all their problems, even the most insignificant, then stay where you are, as you are. If you still have not guessed that you are bread for the hungry, a voice for the old man without heirs, sleep for those who dread night, if you have not understood all this and more: that every wait is a wait for you, then you are telling the truth: indeed, it is not you that mankind is waiting for."

The Rebbe came back to earth, gathered his disciples and forbade them to despair:

"And now," he said, *"the true waiting begins."*

(Which in turn may help explain Kafka's cryptic comment that "The Messiah will come only when he is no longer needed; he will come only on the day after his arrival; he will not come on the last day but on the very last." Kafka, who also once asked, "What have I in common with the Jews? I have hardly anything in common *with myself* and should stand very quietly in a corner, content that I can breathe." In itself one of the most quintessentially Jewish things ever said, particularly within the stream of thoroughly assimilated Jewry to which he himself belonged.)

But not all such Hassidic tales were so confrontational. Thus Elie Wiesel once again, in a strangely lighter (or shall we say, less despairing) vein, from the preface to his 1964 book *The Gates of the Forest*:

When the great Rabbi Israel Baal Shem-Tov
Saw misfortune threatening the Jews
It was his custom
To go into a certain part of the forest to meditate.
There he would light a fire,
Say a special prayer,
And the miracle would be accomplished
And the misfortune averted.

Later when his disciple,
The celebrated Magid of Mezritch,
Had occasion, for the same reason,
To intercede with heaven,
He would go to the same place in the forest
And say: "Master of the Universe, listen!
I do not know how to light the fire,
But I am still able to say the prayer."
And again the miracle would be accomplished.

Still later, Rabbi Moshe-Leib of Sasov,
In order to save his people once more,
Would go into the forest and say:
"I do not know how to light the fire,
I do not know the prayer,
But I know the place
And this must be sufficient."
It was sufficient and the miracle was accomplished.

Then it fell to Rabbi Israel of Rizhyn

To overcome misfortune.
Sitting in his armchair, his head in his hands,
He spoke to God: "I am unable to light the fire
And I do not know the prayer;
I cannot even find the place in the forest.
All I can do is to tell the story,
And this must be sufficient."
And it was sufficient.

To which, Wiesel adds the summary gloss: "God made man because he loves stories."

And—as Voltaire, Twain, and Wedekind would no doubt have insisted—just as surely the other way around.

But oy, that Elie Wiesel: The man could be so annoying, so cringingly and crushingly sanctimonious and overbearing, but damn, the guy sure could tell a good story.

Which in turn brings me round to the late great Larry McMurtry. Remember that note I wrote to Mr. Shawn about how I couldn't write fiction (see footnote 12 above)? Actually there was a second half to that typewritten memo of mine, which Shawn also included in that week's Notes and Comments, which I take the liberty of including here in commemoration of McMurtry's recent passing), to wit:

All these thoughts have come to the fore for me just now on account of my recent summer reading. Larry McMurtry, one of my favorite novelists, has a big new novel out, the epic that all of us McMurtry fans have been hearing rumors about for years. It's called

Lonesome Dove; it basically concerns a cattle drive from southernmost Texas all the way to the highlands of Montana back in the late 1870s, around the time Montana was be-

Larry McMurtry

ginning to be made safe for settling (or, actually, as the novel reveals, it was at precisely this time that brash exploits by characters such as these were going to make that north country safe for settling, although it sure as hell wasn't yet); and it's a wonderful book. McMurtry's ongoing capacity for fashioning fully living characters—filled with contradictions and teeming with fellow-feeling—is in full bloom here; he's created dozens of them, and he's managed to keep them all vividly distinct. Reading the book, one begins to think of the novelist himself as trail driver, guiding and prodding his characters along: some tarry, others bolt and, after a long, meandering chase, have to be herded back into the main herd; others fall out and stay behind; still others just die off. Why does he, I marvel—how can he—keep driving them along like that, from the lazy, languid Rio Grande cusp of Chapter 1 to the awesome Montana highlands past page 800? In many ways, McMurtry strikes me as not unlike his character Captain Call, the leader of the drive, who just does it and, and

keeps on doing it as, one by one, all conceivable motivations and rationales slip away. And yet, unlike Call, McMurtry seems overflowing with empathy for every one of his creatures—a lavishment of love which makes his ability, his negative capability, to then just let them go (after lavishing so much compassion in the fashioning of them), to just let them drift into ever more terrible demises—all the more remarkable.

I have so many questions to ask McMurtry about how he does it. But he wouldn't much cotton to my coming around and asking them. I know: I tried once. McMurtry lives part of the time in Washington, DC these days, where he runs a rare-book emporium in Georgetown. I remember, about five years ago, arriving by tram at Union Station and looking up the store's name in the phone book and calling the number from a payphone and asking the answering male voice whether Mr. McMurtry was in and being told yes, it was he speaking. I said, "Great, don't move, I'll be right over." I hailed a taxi and was there in less than ten minutes. I started out pouring forth praise and appreciation and heartfelt readerly thanks, and then headed into my few questions. And all the while he stared back at me, completely indifferent. The sheer extent of his indifference was terrifying. I ended up stammering some sort of gaga apology and bolting.

A few weeks ago, two of McMurtry's more

recent novels were reissued in paperback—timed, I suppose, to coincide with the hardcover publication of *Lonesome Dove*. They included new prefaces, and these prefaces helped me to appreciate the icy reluctance to talk about his own writing with which he greeted me that day. "I rarely think of my own books, once I finish them," he records in the preface to *Cadillac Jack*, "and don't welcome the opportunity, much less the necessity, of thinking about them. The moving finger writes, and keeps moving; thinking about them while I'm writing them is often hard enough." In the preface to *The Desert Rose* he plays a variation on this theme: "Once I finish a book, it vanishes from my mental picture as rapidly as the road runner in the cartoon. I don't expect to see it or think about it again for a decade or so, if ever." But those prefaces nevertheless suggest the contours of some answers to the sorts of questions I wanted to ask: questions about creators and creatures, free will and determinism—finally, I guess, about grace. At one point, he writes about the way one of his characters, Harmony, in *The Desert Rose*, "graced" his life during the time he was writing about her. (That's a good, an exact, word; I remember how she graced my life, too, as I read about her.) "In my own practice," he notes, "writing fiction has always seemed a semiconscious activity. I concentrate so hard on visualizing my characters that my actual surroundings

blur. My characters seem to be speeding through their lives—I have to type unflaggingly in order to keep them in sight." Later, he records that he was "rather sorry," as he finished the book's composition, when Harmony "strolled out of hearing."

Characters stroll out of hearing all the time in *Lonesome Dove*, and strolling's not the half of it. They lurch, careen, and smash out of hearing: they get snake bitten, drowned, hanged, gangrened, struck by lightning, bow-and-arrowed. The untamed West of *Lonesome Dove* is a tremendously dangerous wilderness. McMurtry offers a luminous epigraph to his epic, some lines from T.K. Whipple's *Study Out The Land*: "All America lies at the end of the wilderness road, and our past is not a dead past, but still lives in us. Our forefathers had civilization inside themselves, the wild outside. We live in the civilization they created, but within us the wilderness still lingers. What they dreamed, we live, and what they lived, we dream." It occurs to me that as a reader I stand in somewhat the same relationship to McMurtry as that which Whipple suggests obtains between us and our forebears. Here McMurtry has gone and done it—created this tremendous epic massif. All the while, as he was doing it, he must have been envisioning us someday reading his epic; and now we, as we read it—or, anyway, I, as I read it—try to imagine what it was like for him doing it, making it, living through the writing of it. And the

thing I keep wondering about, in my clumsy, gawky fashion, is this: Did he, too, feel the sorrow, the poignant melancholy, that he engenders in us as, one by one, he disposed of those, his beloved characters; or was he able merely to glory in the craft of it, the polish, and the shine? Are they—his characters—more or less real for him than they are for us?

Oooh boy, how did we end up here? Talk about digressions on top of digressions (Turtles, I tell you, *turtles*, all the way down). And yet I can't help feeling that all of it—*all of it*—still has something to do with Shimmel Zohar, or so I anyway pray that I will yet be able to convince you, my Dear Sorely Put-Upon Reader.

Detail of *Chemist*

17th Century Alchemists Lab

15 {pg. 35} Striking in turn how many of the Kabbalists at the same time dabbled in alchemy—and how similar the hydraulics of the Sefirot array could at times seem to convoluted splay of vessels and tubes in the traditional alchemist's laboratory, which in turn gets referenced in

Zohar's wet-collodion print of his own contemporary, the alchemist's worthy heir, that *Chemist Developing Non-Humorous Laughing Gas* (which brings us back, by a commodious vicus of recirculation, to our young friend "David after Dentist" (see page 30 and footnote 11 above).

All of which (you know me, or at any rate ought to be beginning to by now) reminds me of a season about ten years back that I spent as a visiting scholar at the Getty Research Institute in Los Angeles. Early on I was invited over to meet with Jim Wood, the president and the chief executive of the entire Getty operation, whom I'd known in an earlier incarnation when he was directing the Art Institute of Chicago while I happened to be artistic-directoring the Chicago Humanities Festival. At our brief meeting there, Wood explained that he had been particularly interested in having me spend a season at the Institute in the hopes that I might in passing come up with suggestions for shaking the whole Getty operation out of its perhaps overly staid and disciplinarily siloed approach to its activities.

And so I kept the suggestion in the back of my mind during the ensuing weeks as I pursued my own scholarly intentions, and one day, it happened that I was lunching with one of the rare-book librarians of the marvelously endowed Institute collection, and between us we got to blue-skying the possibilities of a show I'd been fantasizing about (do you guys happen to have this, I'd ask the librarian, and invariably he'd say, Yes, we have several of those—and this? But of course, and so forth). I literally sketched the

thing out on a napkin as we proceeded, and I presently returned to my office at the Institute and wrote up the proposal. To wit:

<div style="text-align:center">

Lead into Gold:
Proposal for a little jewel-box exhibit
surveying the Age-Old Quest
To Wrest Something from Nothing,
from the Philosopher's Stone
through Subprime Loans

</div>

The boutique-sized (four-room) show would be called **"Lead into Gold"** and would track the alchemical passion—from its prehistory in the **memory palaces** of late antiquity through the middle ages (the elaborate mnemonic techniques whereby monks and clerks stored astonishing amounts of details in their minds by placing them in ever expanding imaginary structures, forebears, as it were, to the physical wondercabinets of the later medieval period—subject of a sort of foyer to the exhibition); into its high classic phase (the show's first long room) with **alchemy as pre-chemistry** (with maguses actually trying, that is, to turn physical lead into physical gold, all the beakers and flasks and retorts, etc.) and **astrology as pre-astronomy** (the whole deliriously marvelous sixteenth-into-seventeenth centuries), with Isaac Newton serving as a key figure here, recast no longer in his role as the first of the moderns so much as the Last of the Sumerians (as an astonished John Maynard Keynes dubbed him, upon stumbling

on a cache of thousands of pages of his Cambridge forebear's detailed alchemical notes, not just from his early years before the *Principia*, but from throughout his life!).

The show would then branch off in two directions, in a sort of Y configuration. To one side:

1) **The Golden Path**, which is to say the growing conviction among maguses and their progeny during the later early modern period that the point was *allegorical,* a call to *soul-work*, in which one was called upon to try to refine the leaden parts of oneself into ever more perfect golden forms, hence Faustus and Prospero through Jung, with those magi Leibniz and Newton riffing off Kabbalistic meditations on Infinity and stumbling instead onto the infinitesimal as they invent the Calculus, in turn eventually opening out (by way of Blake) onto all those sixties versions, the dawning of the Age of Aquarius, etc., which set the stage for the *Whole Earth Catalog* and all those kid-maguses working in their garages (developing both hardware and software: fashioning the calculus into material reality), presently culminating in the Web itself (latter-day version of those original memory palaces from back in the show's foyer, writ large);

while, branching off to the other side, we would have:

2) **The Leaden Path**, in which moneychangers and presently bankers decided to cut to the chase, for, after all, who needed lead and who needed gold and for god's sake who needed a more perfect soul when you could simply

turn any old crap into money (!)—thus, for example, the South Sea Bubble, in which Newton lost the equivalent of a million dollars (whereupon he declared that he could understand the transit of stars but not the madness of men), tulipomania, etc., and thence onward to Freud (rather than Jung) and his conception of "filthy lucre" and Soros (with his book, *The Alchemy of Finance*), with the Calculus showing up again across ever more elaborate permutations, leading on through Ponzi and Gecko (by way of Ayn Rand and Alan "The Wizard" Greenspan) to the whole derivatives bubble/tumor, as adumbrated in part by my own main man, the money artist JSG Boggs, and then on past that to the purest mechanism ever conceived for generating fast money out of crap: meth labs (which deploy exactly *but exactly* the same equipment as the original alchemists, beakers and flasks and retorts, to accomplish the literal-leaden version of what they were after, the turning of filth into lucre).

And I appended a xerox of that napkin sketch.

A few days later I joined my rare-book librarian friend once again for lunch and showed him my proposal, and he paged through, laughing, seeming to enjoy himself,

Napkin Sketch by Lawrence Weschler

but he then changed gears, assuring me that there was absolutely no way that such a thing would ever come to pass at the Getty, the idea was way too unorthodox, nice try though. Nevertheless, I decided to pass it by Jim Wood on my way out, so I arranged a second meeting, and much to my delighted surprise, Wood said it all looked good to him and we should see if we couldn't actually try to pull the thing off . . .

Only, alas, two weeks later, returned now to my New York home, I was to hear of the tragic passing of Jim Wood (in altogether absurd California fashion: a heart attack alone while ensconced in his hillside home's sauna)—so that was that, Wood's passing constituting a terrible loss for the Getty, and on a considerably more incidental scale, the end of that particular fantasy of my own.

16 {pg. 37} Those seeking a more detailed and probably more carefully nuanced account of the entire process are urged to consult the internet, where, under "wet collodion," among other solid entries, they may find a very good Getty Museum short video on the history and technical particulars of the process, which as it happens was produced for the Getty by Berkman himself.

17 {pg. 38} Consider in this context, the haunting, haunted motif of the disappeared mothers in Victorian photographs of their babies, as elucidated recently in a fine piece in *The Atlantic* (https://www.theatlantic.com/family/archive/2020/05/victorian-mothers-hidden-pho-

From the book *Hidden Mother* by Laura Larson.

tos-their-babies/611347/): how the mothers were forced to cradle their kids in a stiff embrace so that they would remain stock still for the entire duration of the plate's exposure, but were required to hide themselves since this wasn't supposed to be a photo of the two of them, only of the family's prized newborn.

Talk about enduring duration . . .

Or perhaps more to the point, consider the re-markably hushed stillness of one of the most famous of the earliest chemical photographs, Louis Daguerre's "Boulevard du Temple" from 1838. Stilled, perhaps, because the vista feels so un-cannily empty, and we, its viewers, get to experience the medi-tative silence the im-age engenders. And yet historians have determined, thanks to the shadows cast

Louis Daguerre, *Boulevard du Temple*

by the trees, that in fact the image would have had to be taken around eight in the morning, at the very height of the Parisian rush hour, when the scene would actually have been quite noisy indeed, all bustling with foot and carriage traffic, and the only reason we don't see any of that in the finished plate is that it all got washed out owing to the ten-minute length of the photo's exposure (wherein anything moving simply disappeared). Indeed, look more closely and you will notice how the two discernible figures there in the lower lefthand corner, the bootblack and his client, would have had to be staged, commanded to stand still for the full ten minutes in order for them to appear at all.

In this context, Eadweard Muybridge, forty years later, becomes a fascinating character, since having noticed the same phenomenon during the early 1870s, in his famous panoramas of San Francisco (a virtual ghost town by the look of them, entirely devoid of moving people), he went on, within a few years, to mobilize a whole series of technical innovations, many of them of his own invention (others having to do with new filmstock emulsions that could accommodate ever shorter exposures) to make *movement itself* his subject, in the process playing a key role in the coming invention of motion pictures, as documented, al-

Eadweard Muybridge,
from *San Francisco Panorama*

The Horse in Motion by Eadweard Muybridge, 1878

most exactly one hundred years later, in Thom Andersen's 1975 film *Zoopraxographer.*

At around the same time, in 1976, a twenty-eight-year-old artist named Hiroshi Sugimoto—born and raised in Japan, a recent graduate of the Art Center College of Design in Pasadena—had a vision. As he would subsequently recall (on his own website), "I'm a habitual self-interlocutor. One evening while taking photographs at the American Museum of Natural History in New York, I [asked myself] *'Suppose you shoot a whole movie in a single frame?'* [...] Immediately I began experimenting in order to realize this vision. One afternoon I walked into a cheap cinema in the East Village with a large-format camera. As soon as the movie started-ed, I fixed the shutter at

Hiroshi Sugimoto, from *Theaters*, 1978

a wide-open aperture. When the movie finished two hours later, I clicked the shutter closed. That evening I developed the film, and my vision exploded behind my eyes."

In effect, the result evinced the very obverse of the effect Daguerre and Muybridge had encountered with their ghost town cityscapes. With them, anybody moving in the frame during the necessarily long exposures simply disappeared (and the pavement, say, behind them shone through, precisely because it hadn't been moving). But here, because of all the movement inherent in the moving picture, every single square inch of the screen at some point registered stark white, if only briefly, such that the negative plate eventually burned clean through across the length of its two-hour exposure. And the result looked startlingly like the sort of thing such California Light and Space masters as Douglas Wheeler, James Turrell, and Robert Irwin were straining toward in real life around the same time.

Now, for the longest time, during the 1960s and 70s, Robert Irwin, subject of my first book (*Seeing is Forgetting the Name of the Thing One Sees*, 1982), had forbidden the photographing of any of his works because, as he put it, "photography captures everything the work is not about and nothing that it is, which is to say that it can only capture image and never presence." "Presence"

Doug Wheeler, *Untitled* 1968

being the key term, and a distinctly curious one at that, because counterintuitively, it is in some ways the very opposite of "present." Thus, for example, to be present is to be here right now, to exist, that is, in the absolute immediate present, the infinitesimally compressed synapse between past and future, like a snapshot, whereas "presence" is more like *being* here now, an extended stance maintained across a prolonged moment, precisely like the *duration* Berkman locates, by contrast, in the stilled act of posing required with a wet-collodion print or a daguerreotype.

No sooner had an extended excerpt from that Irwin book appeared in the *New Yorker* of March 8 and 15 of 1982 than I got a call from the artist David Hockney, who told me he disagreed with just about every single thing in my Irwin profile (and indeed, on the surface one could hardly imagine two artists with practices more diametrically opposed), but that he couldn't get the thing out of his head and might I like to drop by and discuss things, an invitation I took him up on later that year, the next time I'd ventured back to Los Angeles.

And as it happened I found him deeply immersed in a photographic project of his own. Hockney was an amateur photographer from way back, an inveterate compiler of "snaps" as he called them, both as documentation of a marvelously peripatetic life and as "studies" in his painting practice, and for that matter his own works were among the very most photographically reproduced of any contemporary artist, with the possible exception of Warhol's. So I was quite surprised when Hockney began con-

fessing that though he'd long thought Irwin's prohibition on the photographic reproduction of *his* work to be a bit fetishistically daft, in recent years he'd developed an increasing respect for Irwin's stand, indeed he wished that he himself had forbidden the reproduction of his own work. "Nowadays," he acknowledged, "it's become very hard for people to come upon one of my paintings, say, in a museum, without filtering the experience through the poster in their dentist's office."

The immediate occasion for Hockney's photographic frenzy at the time turned out to be that a team from the Pompidou in Paris who were preparing a show, precisely, of several prior decades of Hockney's snaps had been visiting a few months earlier. The more Hockney had participated in the selection process, reviewing dozens of scrapbooks, the more problematic those snaps had begun to seem to him, and he'd gotten into several spirited debates with the Pompidou curator Alain Sayag and the rest of his team.

"My main argument," Hockney now recalled for me, "was that a photograph could not be looked at for a long time. Have you noticed that?" He picked up a nearby magazine, thumbing through randomly to an ad, a photograph of a happy family picnicking on a hillside green. "See? You can't look at most photos for more than, say, thirty seconds. It has nothing to do with the subject matter. I first noticed this with erotic photographs, trying to find them lively: you can't. Life is precisely what they don't have—or rather, *time*: *lived time*. All you can do with most ordinary photographs is stare at them—they stare back, blankly—and presently

your concentration begins to fade. They stare you down. I mean, photography is all right if you don't mind looking at the world from the point of view of a paralyzed cyclops— *for a split second*. But that's not what it's like to live in the world, or to convey the experience of living in the world."

"During the last several months," he went on, "I've come to realize that it has something to do with the amount of time that's been put into the image. I mean, Rembrandt spent days, weeks, painting a portrait. You can go to a museum and look at a Rembrandt for hours and you're not going to spend as much time looking as he spent painting—observing, layering his observations, layering the time. Now, the camera was actually invented long before the chemical processes of photography—it was being used by artists in Italy in the sixteenth century in the form of a camera obscura, which is Latin for darkroom. The device consisted of a dark box with a hole in it and a focusing lens in the hole which projected an image of the outside world onto a flat surface at the far side of the box. Canaletto used one in his paintings of Venice. His students would trace the complicated perspectives of the Grand Canal onto the canvas, and then he'd paint the outline in, and the result would appear to confirm the theory of one-point perspective. But in terms of what we've been talking about, it didn't really matter, because the entire process still took time, the hand took time, and though a 'camera' was used, there's no mistaking the layered time. At a museum you can easily spend half an hour looking at a Canaletto and you won't blank out."

"No, the flaw with the camera comes with the inven-

tion of the chemical processes in the nineteenth century. It wasn't that noticeable at first. In the early days, the exposure would last for several seconds, so that the photographs were either of people, concentrated and still, like Nadar's, or of *still* lifes or empty street scenes as in Atget's Paris. You can look at those a bit longer before you blank out. But as the technology improved, the exposure time was compressed to a split second. And the reason you can't look at a photograph for a long time is because there's virtually no time *in it*—the imbalance between the two experiences, the first and second lookings, is too extreme."

The Seyag team had been taking Polaroids of all the snaps they might subsequently be including in the show, and they left behind dozens of cartons of unused Polaroid tiles. And Hockney was soon deploying those in an entirely new fashion, creating elaborate multi-tiled, intricately gridded collages of individual scenes. (As he began showing some of those to me, he asked in passing whether I might be interested in composing the text for a coming coffee-table book of these new "Cameraworks" of his, and I agreed, which is how it happened that several months after that, my introduction to the book of that name was first serialized in the *New Yorke*r of July 9, 1984, and decades later would come to constitute the first chapter of my collection of what with time grew into over twenty-five years of such occasional conversations with Hockney, entitled *True to Life* (University of California Press, 2009; the extended

passages of conversation quoted here are drawn from that first chapter, pp. 6–13).

"From that first day," Hockney recalled, "I was exhilarated. First of all, I immediately realized I'd conquered my problem with time in photography. It takes time to see these pictures—you can look at them for a long time, they invite that sort of looking. But, more importantly, I realized that this sort of picture came closer to how we actually see, which is to say, not all-at-once but rather in discrete, separate glimpses which we then build up into our continuous experience of the world."

By the end of his first week of voracious experimentation, Hockney had already achieved what would prove one of the most fully realized collages in the entire series, a warmly congenial portrait of his friends Christopher Isherwood and Don Bachardy. The two emerged from a grid of 63 Polaroid squares (7 by 9 tiles). Isherwood, the aging master, was seated, a wine glass in his hand and a cheerful gleam in his eye, which was trained upon the camera. The younger Bachardy stood, leaning against the wall and looking down affectionately at his longtime friend. Isherwood's head was basically captured in one square still,

David Hockney, *Don + Christopher, Los Angeles, 6th March 1982* (composite of Polaroid photos)

David Hockney, Warhol & Geldzahler

but Bachardy's hovered, a play of movement, fanned out into five separate squares—that is, five separate vantages, five separate tilts of the head, five distinct moments of friendly concentration. Bachardy's five heads gave the impression of a buzzing bee bobbing about Isherwood's still flower of a face. And yet the five vantages read, immediately, as one head; and indeed, a head no larger than Christopher's. If anything, Isherwood's face is the center of attention, the fulcrum of the image.

Back in 1975, by way of contrast, Hockney went on to explain how he had once snapped a photo of his friend Henry Geldzahler, cigar in hand, making an animated point in a conversation with Andy Warhol. The two were seated, facing each other, and a Great Dane stood guard at Warhol's side, facing the camera. Behind Warhol and Geldzahler was a mirror in which you could see Hockney standing, taking the picture. Behind Hockney was another mirror where, again, you could make out the conversationalists and the dog, only smaller. Strangely, it was only in this second reflection that you noticed that the dog was not real: it was stuffed.

And looking back at the figures of Geldzahler and Warhol, you couldn't really tell the difference. "That's the whole point," Hockney confirmed. "In ordinary photographs, everybody's stuffed." (Zohar might not disagree.) "In this new portrait, however, Isherwood and Bachardy are anything but stuffed. Theirs is a living relationship: it's living right there before your eyes."

Zohar, *Taxidermied Taxidermist*

Which in turn reminds me of an insight I had, years later, about the uncanny sense of lived time one finds in Vermeer, another master of the camera obscura. Because for almost the first time, we had a painter consciously injecting *duration* into his canvases, the time of time *passing*. Others before him had of course portrayed people frozen in stillness, but that is because those people were *posing*: they'd been told to keep still, and there is an inevitable stiffness to the result (as in the early days of chemical photography). But Vermeer often chose instead to portray his women in the midst of *doing things* (pouring milk out of a pitcher, focusing on a *V* of thread, holding up a string of pearls, testing the balance of a set of scales), albeit things that forced them momentarily to stand still in the midst of time as

Vermeer, *Woman with
a Pearl Necklace*

it was passing. In that sense, one can almost see Vermeer as the inventor of cinema. (For more on this notion, see the essay in my "Pillows of Air" column from the *Believer* magazine of March 2004, "Tim's Vermeer—Vermeer's Music Lesson—Marker's La Jetée," available online both via the Believermag.com website and my own at www.lawrenceweschler.com.)

Yikes, again, how I digress. But the reader will perhaps permit me one last excursus before closing this particular note. Because when it came to Hockney's claim that one could only gaze upon a conventional photo for thirty seconds before blanking out, my dear colleague at the *New Yorker*, the splendid Veronica Geng, was having none of it. And she chose a *Harper's* "Annotation" column in that magazine's issue of November 1984 for her inspired rebuttal, "How Long Before You Blank Out?" Citing Hockney's earlier comments from my *New Yorker* piece, she emphatically demurred. Taking, at more or less random, "an ordinary photograph" by James Hamilton, she went on to deploy a stopwatch as she chronicled the length of time it took her to worry out the succession of odder and odder details she took to noticing in the Hamilton snap: those weird ascending helmets; the titles on the books arranged atop the dresser (including *Thus Spake Zarathustra*, Aeschylus's *Oresteia*, and *The Rights of Man*); an extended deconstruction of the patterns on the hostess's housecoat; the

James Hamilton, *Mrs. Sills in Her Husband's Den,*
November 1971, from an article written by Veronica Geng

hunting scene in the painting (probably not a Canaletto,
Geng hazards, though maybe a fake Canaletto?); the liquor
bottles in their soldierly array, and by the time she's finished,
she reports, she's spent nearly forty-five minutes probing the
exquisite particularities of just this ordinary snap. So there.

18 {pg. 39} Thus, for example:

Gal Godot and pals in an outtake scene from *Wonder Woman*

Nicole Kidman in
Cold Mountain

Jude Law in
Cold Mountain

Sam Shepard in
*The Assassination of Jesse James
by the Coward Robert Ford*

Johnny Depp as
Tonto in *The Lone Ranger*

The old-time photographer guy in *The Lone Ranger*

IV

19 {pg. 45} That's right, come to think of it, *nine-teenth-century* moths! The book in question being my 1995 *Mr. Wilson's Cabinet of Wonder: Pronged Ants, Horned Humans, Mice on Toast and other Marvels of Jurassic Technology.*

20 {pg. 47} Although in point of fact Sebastian didn't die of either: To hear Saint Ambrose (Augustine's teacher) tell it—and he is thought to have been the first to do so—Sebastian (about 256–288 CE) was an early Christian martyr who ran afoul of the Roman emperor Diocletian, who in turn ordered the young troublemaker bound to a tree and shot through with arrows. But the arrows didn't kill Sebastian, who was instead rescued and healed by Saint Irene of Rome, whereupon, incorrigible, he up and returned to Diocletian's court to further castigate the emperor for

Saint Sebastian by
Pietro Perugino, c.1495

his sins. Diocletian, for his part, was not amused and instead ordered the young man clubbed to death. Which he was, that in fact being how Sebastian actually died.

Incidentally, I once recounted that joke about the Zenovian Sebastian dying not of his wounds but of fright at an after-event dinner party following the poet Billy Collins's appearance at the Chicago Humanities Festival (which I happened to be artistic-directing at the time), and a few months later I opened that week's *New Yorker* (October 11, 2010) to a poem entitled "Table Talk," which began:

> Not long after we had sat down to dinner
> at a long table in a restaurant in Chicago
> and were deeply engrossed in the heavy menus,
> one of us—a bearded man with a colorful tie—
> asked if any one of us had ever considered
> applying the paradoxes of Zeno to the martyrdom
> of St. Sebastian.

> The differences between these two figures
> were much more striking than the differences
> between the Cornish hen and the trout amandine
> I was wavering between, so I looked up and
> closed my menu.

If, the man with the tie continued,
an object moving through space
will never reach its destination because it is always
limited to cutting the distance to its goal in half,

then it turns out that St. Sebastian did not die
from the wounds inflicted by the arrows.
No, the cause of death was fright at the spectacle
 of their endless approach.
St. Sebastian, according to Zeno, would have died
 of a heart attack.

I think I'll have the trout, I told the waiter,
for it was now my turn to order,
but all through the elegant dinner
I kept thinking of the arrows forever nearing

the pale, quivering flesh of St. Sebastian
a fleet of them perpetually halving the tiny distances
to his body, tied to a post with rope,
even after the archers had packed
 it in and gone home {...}

And going on from there. Of course the poet was Billy
Collins and "the man in the colorful tie" was me, I, the
author of this footnote . . . (Do yourselves a favor, though,
and track the rest of the poem down online or in his 2011
collection *Horoscopes for the Dead*; it just keeps getting
better and better, the closer it gets to its end.)

But the thing of it is, that wasn't even the first time this sort of thing had happened to me. Several years earlier, I'd undertaken a reporting trip in South Africa and, long story, but soon after my return to New York I happened to be at another sort of literary soiree and found myself relating a wonderfully apt joke I'd happened to hear down there to the poet Robert Pinsky—to be specific, the Belgian Army Joke (way too long to relate here—it involves a battle royale between Flemish and Walloon soldiers at their barracks and the intervention of their general, the punchline being "Rabinowitz, Sir!"), and sure enough, not six months later, I happened to open my just-arrived issue of the *Threepenny Review* (Winter 1995) to a very long poem entitled "Impossible to Tell," and my eyes quickly snagged upon the words "Walloons," "Flemish," "Belgian Army," and up a few lines, the phrase, "There's one a journalist told me," and then down to the name of the poem's author: Robert Pinsky, of course . . . A great poem, incidentally, and like the Collins, also about jokes and death (you can find it also online, or else in Pinsky's *The Figured Wheel* collection, 1996), but I ended up writing a letter to the editor of the *Threepenny Review* (which I subsequently included in my own 2012 collection, *Uncanny Valley: Further Adventures in the Narrative*) in which I detailed the precise circumstances in which I myself had first heard the joke, just who had told it to me and why, concluding my comments (more gracefully, I now see, reading the letter all over again, than I had remembered) by wondering whether "these jokes themselves were the only truly living things on this planet, and we humans merely

the stories they tell themselves between-tides as they flit so merrily about, all of mankind being merely the medium in which they play out their eternally self-renewing and mischievous liveliness."

What I'd meant to say—what I thought I'd said—was how I really do have to stop telling jokes to poets.

But yeah, so where was I? Oh yeah, on Zeno's paradox, which reminds me of another joke, the one about the two Oxford dons, a mathematician and an engineer, who find themselves in the college quad conversing about the bedeviling confoundments of the paradox (the business of getting halfway there and halfway the remainder and halfway the remainder of that) when just then (trigger warning!) a beautiful woman goes striding by (but seriously, if this bothers you, just flip the genders), and the mathematician, gazing upon the lady and still pondering the intricacies of the paradox, despairs of ever being able to attain her, but the engineer knows he can get *close enough for all practical purposes.*

Probably better never tell that one to a poet, though, on the other hand, likely none would dare to retell it in the current cultural moment. In fact, just forget I ever mentioned it, you didn't hear it from me.

21 {pg. 47} Guy goes to the rabbi. "Rabbi," he wails, "you gotta help me. I've got this problem, and I just can't seem to crack the thing. I look at it this way, no progress. I turn it over this other way, nothing doing. I let it steep for a few days, try again: zilch. I hazard a whole other approach—complete blockage. Nothing, no way, nada."

"Maybe," hazards the Rabbi, "it's not your problem."

V

22 {pg.49} Not to careen too far off track here, or to be seen too much to be tooting my own horn, as it were, but I will confess that my favorite review ever of my own work began by noting that any master of long-form nonfiction requires "the vision of a novelist and the precise ear of a poet, but just as important is the journalistic nose which can steer him down the proverbial alley," concluding, "Weschler's is an unusually fabulous nose."

Well, as long as we've careened that far, I might as well tell you another story. This one is absolutely true, swear to god. Back in high school in the San Fernando Valley in suburban LA, one of my favorite teachers was Miss—(this would have been 1969, so, yes, *Miss*) well, let's call her Susie Kay Krefeld, our AP English Lit prof. Bawdy and bodacious, zaftig and curvaceous, after class she would regularly entertain a coterie of her most nerdily pitched hangers-on, of which I was certainly one, with outré narratives of the wider literary world, alongside tales of her own outlandish sexual exploits (how she'd sequentially bedded every single one of the school's male PE coaches, as well, over the years, as a good many of the school's championship senior quarterbacks)—as I say, this was a different time, this was the Sixties: please, Dear Reader, forgive us and forgive her, we nerds certainly weren't victims here.

Anyway, the last week of that final semester, as I was

leaving that day's class, she pulled me aside and asked me to drop by her office after school, there was something, she said, that she wanted to share with me. The rest of the day was for me a hormonal wash, my heart doing racing backflips, my mind agog in steamy anticipation.

The moment came, I tentatively knocked on her door, she bade me enter and to close the door behind me. I stood there tongue-tied for a few moments as she seemed to gauge me silently, up and down, with her doey eyes. "Naah," she pronounced, at length, "we better not." *Mmm-nnn-ggg?* I countered, cogently. "No," she repeated. "It would just ruin our friendship, best to leave things be." *Really?* I somehow managed, *why? what? Maybe it wouldn't.* "You want me to?" she doubled back, "It wouldn't ruin things for you?" To which I reverted once again to strangulated whimpers.

"Well, okay then," she resolved, getting up from behind her desk, swayingly sashaying toward me and reaching out for my face.

"It's your nose," she declared. Two beats, three. "Really, Lawrence, you have to do something about that nose."

Continuing: "I mean, I should know, I had the same problem. Tell me it's not the same with you: Out driving, you pull up to a stop sign and a car pulls up alongside you, and you notice how you drag your hand up so as to block all view of that schnoz." Actually, I couldn't remember doing any such thing (though I wasn't out driving all that often, it occurred to me). "You're subconsciously agonizing about it all the time," she assured me. "It's wreaking havoc on your self-confidence." But was it? I didn't think it was. "When I

was your age," she continued, "I went and got mine taken care of the minute I could"—it occurred to me that I'd never particularly taken in her nose (maybe that was the whole point) but now that I did, yes, it was perfectly straight, tapering down to a fetching button, I supposed—"and that decision has made all the difference." (Damn if I didn't catch the Robert Frost reference, but what good was that doing me?)

Returning to her desk and leaning against its side, crossing her lithe arms athwart her ample and considerably more fetching chest (those breasts that could so easily have been mine, as I couldn't help but recognize, if only I'd instead been born a pea-brained pug-nosed championship quarterback), Miss Krefeld let out a lilting sigh and, "There," she assured us both, "that wasn't so bad, now, was it? And it had to be said." Going on to dismiss me, "You just think about it."

And over the years I often have, though not perhaps as she intended: I have no idea how I survived high school.

23 {pg. 49} For more on this sort of drama, see *Fictions of the Pose,* the magnum opus of my own master at UC Santa Cruz, the eminent recently deceased cultural critic Harry Berger Jr., in which among other things, the good professor anatomizes the ever-tumbling contest between the painter and his/her subject for command of the representation of self (and whose self? the painter's or the subject's? especially when one was dealing with a self-portrait). Sure, the book is utterly revealing when it comes to Rembrandt

and Lotto and Bronzino—but really, it ought to be required reading in just about any journalism course.

24 {pg. 50} In fact, the coincidence of profiles put me in mind of another such pairing, or in fact pair of pairings, from years earlier, back in the days just after high school, when I used to serve as my widowed grandmother Lilly Toch's co-host at the dinners she would throw for her high-cultured friends in Santa Monica (and come to think of it, driving over from the Valley, I really don't remember ever having shielded my nose from any sneering side-glances). Anyway, my grandmother and I had a little game in which every such evening after dessert, we'd have the assembled company retire to my grandfather's old study for drinks, and Lilly would sink into a comfy sofa under an oil portrait of her Viennese great-grandmother while I, on the other side of the room, established myself in a corner under a bust of her

Portraits of Lawrence Weschler's grandmother
(left) and her great-grandmother (right)

Lawrence and bust of his
grandfather, composer Ernst Toch

late husband, my grandfather Ernst, without so much as a comment from either of us, thereby invariably blowing the minds of everyone present (as furtive glances passed from the one of us to the other). The bust, incidentally, was by Anna Mahler, the daughter of Alma and Gustav—and you will note how neither of us seems to feel the need to shield our noses.

25 {pg. 53}: The phenomenon Berkman was encountering here, across the only-seemingly-blank page with its fugitive impress, is referred to, in printer's jargon, as "ghosting," which is to say a faint image on a sheet of paper where it was not intended to appear. But the image of that appearance, as Berkman showed me its copy, put me in mind of another such instance in the history of art, another such only-seemingly-blank page, if you will (and if so willing, perhaps you will bear with me).

I am referring to the young Robert Rauschenberg's legendary encounter with the great Willem de Kooning. At that moment, in 1953, de Kooning (b. 1904) was, alongside Jackson Pollock (b. 1912), arguably the reigning master of the New York art scene, proponent of that spec-

tacularly vigorous, existentially torqued, action painting style known as Abstract Expressionism. Not only a great, great painter, he was also one of the most accomplished and subtle draftsmen of all time. Protean creator of this sort of thing, from MOMA's collection (1952):

Anyway, Rauschenberg (b. 1925) was fairly new in town, a generation young-

Willem de Kooning,
Seated Woman, 1952

er than de Kooning, fresh out of Black Mountain College (where his teachers and fellow students had included the likes of Merce Cunningham, John Cage, Josef Albers, Buckminster Fuller, and Jasper Johns). Unlike other younger artists in New York at the time (Resnick, Bluhm, Goldberg, Mitchell, and other such), Rauschenberg, though an enormous admirer of de Kooning's achievement, was himself declining to pursue the so-called Second Generation Abstract Expressionist path. Instead, for example, just around that time, he'd been executing a series of "White Paintings," exclusively monochromatic works that eschewed emotionally expressionist gesture altogether, intent instead on exploring and celebrating the perceptual fundament undergirding all expression, the positive active presence of that otherwise fugitive color, the way light itself for ex-

ample played across such an emptied canvas. White paint
on white canvas was one thing, however, but somewhere
in there, Rauschenberg got it into his head that he wanted
to follow such experiments into the terrain of drawing,
another great passion of his, even though it was not alto-
gether clear, initially, how one might go about doing such
a thing. Presently he hit upon the idea of erasing drawings
and began doing so, for starters, with drawings of his own,
becoming increasingly entranced with the resultant trace,
the look, as it were, of the gummy smudge.

The story has been told many times (see for example
the accounts in Mark Stevens and Annalyn Swan's Pulitzer
Prize–winning 2004 biography, *De Kooning: An American
Master*; or in the PBS *Modern Masters* documentary on
Rauschenberg, available on YouTube). Something about eras-
ing his own drawings was failing to fully satisfy the young
Rauschenberg (they looked too much, he felt, like erased
Rauschenbergs, and as such, perhaps, not accomplished
enough, or at any rate too self-referential, which was never
the point), and presently he convinced himself that what he
needed to be doing instead was to erase the work of a full-
fledged master; whereupon, screwing up his courage with a
bottle of Jack Daniels, he ventured over to de Koonings's stu-
dio and asked the revered master for a drawing, stammering-
ly explaining how he intended to erase it. Willem de Kooning,
for his part, took the request entirely seriously, and following
all sorts of excruciating mind games of his own, gave the
young whippersnapper a page of densely worked imagery,
scrawled over with all manner of crayon, pencil and ink.

What I've always savored at this point in the story is the evident comedy of misunderstanding: de Kooning clearly interpreted the request in active expressionist terms, as a laying down of the gauntlet in an epic generational battle. Just as he, de Kooning, had had to slay Picasso in order to clear space for himself, here coming up was this new generation, intent on engaging in its own Oedipal rebellion. Talk about existentialist passion! So he met the challenge head on, giving the boy a particularly densely worked page that would prove especially difficult, if not impossible, to erase. Whereas for Rauschenberg, the thing was (or so he was always to claim), Oedipal aspirations had nothing to do with it; nor even did the process of erasure, which in this instance was indeed to last several months; he insisted that he simply loved how the gummy erasure smears *looked*.

The way they reflected the room, for example, the Zen-like attention they invited and sustained. For him, they weren't gestures of nihilist defiance; rather, they constituted a sort of "poetry." (John Cage, for his part, credited Rauschenberg's white on white experiments with giving him the courage, immedi-

Robert Rauschenberg,
Erased de Kooning Drawing, 1953

ately thereafter, to begin pursuing his own extended evocations of silence.)

Anyway, all of this now came back to me, looking at that empty page of Berkman's with its after-image shimmering or not just beyond its surface (I *told* you we'd get there eventually if you just bore with me!). But I couldn't help free-associating to the work of an artist from the immediately following generation, how, observing the de Kooning–Rauschenberg battle—the Old Man seized by the anguished Oedipal implications of the erasing gesture, and the Younger Man by the splendor of its look—Claes Oldenburg (b. 1929) in effect, the grandson in this configuration, would subsequently take to proclaiming: Forget the erasure, *look at the Eraser!* Look how beautiful *it* is!

Claes Oldenburg eraser
Typewriter Eraser, Scale X, model 1998, 1999

And anyway (if you will permit me one last associational cartwheel), all of that somehow reminded me of a passage from my old *New Yorker* colleague Ian Frazier's magnificent book *Travels in Siberia* (2010), where he related how:

> Having read a lot about the end of Tsar Nicholas II and his family and servants, I wanted to see the place in Yekaterinburg where the event occurred. The gloomy quality of this quest depressed [Frazier's guide] Sergei's spirits, but he drove all over Yekaterinburg searching for the site nonetheless. Whenever he stopped and asked a pedestrian how to get to the house where Nicholas II was murdered, the reaction was a wince. Several people simply walked away. But eventually, after a lot of asking, Sergei found the location. It was on a low ridge at the end of town, above the railroad tracks and the Iset River. The house, known as the Ipatiev House, was no longer standing, and the basement where the actual killings happened had been filled in. I found the blankness of the place sinister and dizzying. It reminded me of an erasure done so determinedly that it had worn a hole through the page.

Which in turn set me to thinking a bit further about that legendary de Kooning–Rauschenberg encounter, for look again at the year: 1953. Height of the Cold War, and indeed the very year Stalin himself died. Stalin, that gruesome master of the political erasure, as subsequently documented

David King, 1997, *The Commissar Vanishes* book cover

by David King in his 1997 classic *The Commissar Vanishes*:

A tyrant who became convinced that it wasn't just necessary to eliminate one's opponents—his own legitimacy, he became ever more obsessively certain, resting on his erasing all evidence that they had ever existed at all. Culminating with Himself All Alone, triumphant, unchallenged and unchallengeable, supremely sovereign against a serene white on white backdrop. Talk about ghosting.

But I know, I know: I digress. Still, if you will permit me just one further footnote, as it were, to that last association: just a few years ago, in 2017, as the studio was seeding the ground for the forthcoming release of Armando Iannucci's marvelous historical satire *The Death of Stalin* with a blitz advertising campaign featuring an array of profiles of the film's puffed-up star figures, one of those stars, Jeffrey Tambor (playing the weaselly Georgy Malenkov), suddenly found himself the subject of accusations of sexual impropriety (charges he fiercely denied) on the set of his earlier thrice Emmy-nominated gig as the transitioning (male to female) father on the series *Transparent*. No sooner

Jeffrey Tambor (in middle of left poster):
Now you see him, now you don't.

was he literally canceled from the eponymous role on that series than he also, pouf, found his image (and character) summarily vanishing from the ads for the upcoming Stalin movie. Replaced by a woman, no less!

First time tragedy, as Marx himself might have observed: second time farce.

26 {pg. 53} See these excerpts from e.e. cummings' foreword to his collection *Is 5* (and grant the guy a little slack, this was 1926, after all, almost a hundred years ago):

> On the assumption that my technique is either complicated or original or both, the publishers have politely requested me to write an introduction to this book.

At least my theory of technique, if I have one, is very far from original; nor is it complicated. I can express it in fifteen words, by quoting The Eternal Question And Immortal Answer of burlesk, viz. "Would you hit a woman with a child?—No, I'd hit her with a brick." Like the burlesk comedian, I am abnormally fond of that precision which creates movement.

If a poet is anybody, he is somebody to whom things made matter very little—somebody who is obsessed by Making {....} Ineluctable preoccupation with The Verb gives a poet one priceless advantage {however}: whereas nonmakers must content themselves with the merely undeniable fact that two times two is four, he rejoices in a purely irresistible truth (to be found, in abbreviated costume, upon the title page of the present volume).

cummings Melville

27 {pg. 54} In a recent communiqué, Berkman reminded me that Herman Melville was born on August 1, 1819, just up the street from Zohar Studios, at 6 Pearl Street. And

how today, just across the street from that address sits a Starbucks, the coffee franchise named after one of Melville's most memorable characters. For that matter, he averred as to how the character depicted in a photo illustrating the somnambulist's notes for Zohar's *Study for a Painting*, "with his spiral jetty sideburns, bears a striking resemblance to Melville's marvelous character Queequeg in *Moby Dick*."

28 {pg. 57} Around here, in the midst of this seemingly endless outpouring of Berkman's, I began to recall how in solid matter physics, the greatest superconductors, which is to say materials with the highest capacity for passing electricity through with the least resistance, sometimes turn out to be ever so slightly tweaked variations of the most efficient insulators, which is to say materials with the greatest capacity otherwise for preventing any such passage at all. The slightest tweak and blockage suddenly gives way to flood-surge.

29 {pg. 57} Indeed, Gorky's closed in 1993, and for that matter Elli Buk passed away in 2012, and the Chelsea Flea Market closed, after a forty-year run, the very week we were wrapping up the *Predicting the Past* exhibition catalog, in response to which Berkman noted, "It's been so strange with this project, trying to reclaim the lost world of the mid-nineteenth century as our very own world seems to be disappearing all around us."

30 {pg. 58} Talk about coincidences, I also happened

Gorky

to know about that article. The eminent film and sound editor Walter Murch once sent it in to the McSweeneys website in the context of a contest we were running in conjunction with the publication, under their imprint, of my book *Everything That Rises* (2006). And you can find our whole exchange, along with Gorky's entire piece, by Googling "McSweeneys.net, Convergence Contest, Murch, Gorky."

Several things stand out in Gorky's 1895 text, beginning quite simply with how startling and uncanny he'd found the entire experience, and from the very start: "Last night," Gorky launches out, "I was in the Kingdom of Shadows":

> If you only knew how strange it is to be there. It is a world without sound, without colour. Everything there—the earth, the trees, the people, the water and the air—is dipped in monotonous grey. Grey rays of the sun across the grey sky, grey eyes in grey faces, and the leaves of the trees are ashen grey. It is not life but its shadow. It is not motion but its soundless spectre.
>
> Here I shall try to explain myself, lest I be suspected of madness or indulgence in symbolism. I was at Aumont's and saw Lumière's cinematograph—

moving photography. The extraordinary impression it creates is so unique and complex that I doubt my ability to describe it with all its nuances. However, I shall try to convey its fundamentals. When the lights go out in the room in which Lumière's invention is shown, there suddenly appears on the screen a large grey picture, "A Street in Paris"—shadows of a bad engraving. As you gaze at it, you see carriages, buildings and people in various poses, all frozen into immobility.

All this is in grey, and the sky above is also grey— you anticipate nothing new in this all too familiar scene, for you have seen pictures of Paris streets more than once. But suddenly a strange flicker passes through the screen and the picture stirs to life. Carriages coming from somewhere in the perspective of the picture are moving straight at you, into the darkness in which you sit; somewhere from afar people appear and loom larger as they come closer to you; in the foreground children are playing with a dog, bicyclists tear along, and pedestrians cross the street picking their way among the carriages. All this moves, teems with life and, upon approaching the edge of the screen, vanishes somewhere beyond it.

And all this in strange silence where no rumble of the wheels is heard, no sound of footsteps or of speech. Nothing. Not a single note of the intricate symphony that always accompanies the movements of people. Noiselessly, the ashen-grey foliage of the trees sways

in the wind, and the grey silhouettes of the people,
as though condemned to eternal silence and cruelly
punished by being deprived of all the colours of life,
glide noiselessly along the grey ground.

Remarkable how for Gorky, the very aspects we project
onto the past, the late nineteenth through early twentieth
centuries, almost to the point of forgetting that they couldn't
possibly in fact have been so—how everybody back then
would have lived in a world entirely immured in black and
white, and for that matter, in silence (that of course being
how everything inevitably appears in those early films)—
that all of that would have been as unsettlingly strange to
a contemporary witness of the novel medium.

Indeed, it would have been just as strange for them as,
conversely, it would be for us today to encounter straight-up
color photos of the people of that time, as one in fact does
in this other Russian instance: the pioneering color pho-
tography of Sergei Mikhailovich Prokudin-Gorskii, from
1909 (!), undertaken under a commission by Tsar Nicholas

Color images by Sergei Mikhailovich Prokudin-Gorskii
commissioned by Tsar Nicholas II

II (and collected in the 1980 book *Photographs for the Tsar*, edited and with an introduction by Robert Allhouse).

And then, for good measure, this →

Returning, though, to Gorky's captivating 1895 account of first witnessing moving pictures in St. Petersburg: amazing, too, how literally within just a few months of the invention of this entire revolutionary process, Gorky had it all figured out. He'd realized

Granted: not Gorky.
But Tolstoy! In color!

that while the subjects of the medium's first attempts were still fairly banal—a horse cart trotting down a city lane, a train pulling into the station, people having lunch al fresco, and so forth—once its entrepreneurs finally got around to featuring sex and violence, he predicted, the thing was really going to take off, concluding his piece thusly:

> I am convinced that these pictures will soon be replaced by others of a genre more suited to the general tone of the "Concert Parisien." For example, they will show a picture titled: "As She Undresses," or "Madam at Her Bath," or "A Woman in Stockings." They could also depict a sordid squabble between a husband and wife and serve it to the public under the heading of "The Blessings of Family Life."
>
> Yes, no doubt, this is how it will be done. The bucolic and the idyll could not possibly find their place in Russia's markets thirsting for the piquant and the

extravagant. I also could suggest a few themes for development by means of a cinematograph and for the amusement of the market place. For instance: to impale some fashionable social parasite upon a picket fence, as is the way of the Turks, photograph him, then show it.

Not exactly piquant but it would be quite edifying.

31 {pg. 59} A long time ago, back in my days at UC Santa Cruz, my friend Joel Rosenberg, a grad student at the time in the History of Consciousness program (*Go, Banana Slugs, Go!*), showed me the typescript of a translation he'd just rendered of a tale (circa 1800) told by the eminent Hasidic rebbe Nachman of Bratslav. The story stayed with me through the decades, and for some reason it comes back to me here and now as well:

```
       The Portrait of the King

   Once there was a king who had a wise man.
The king said to the wise man: I know a place
where there is a king. It seems he is known as
a GREAT and MIGHTY man, and a man HUMBLE and
TRUE. I know for a fact he is mighty: the sea
surrounds his kingdom, and on this sea stand
battleships that let no one pass, and inside
the sea is a huge SWAMP surrounding the king-
dom, with only one path wide enough for one
person to travel, and anyone who tries they
```

SHOOT. Except one who is known to be true and humble. More than this I know not, but I want you to bring me a picture of that king: in his portrait is the portrait of all kings. But no king has his portrait because he is unseen by any person. He is BENEATH IT ALL. He is far from the people of his kingdom.

The wise man went to the kingdom. He said to himself: it will be a good idea to get to know the nature of the kingdom, and WHAT BET-TER WAY than by its HUMOR? When one wants to know a thing, one must know its humor. For example, sometimes a person really wants to do harm to another, and when the latter cries out in complaint, the person says, "I'm only joking." And sometimes a person only intends a joke but winds up harming another person with his words.

(Now there is among all countries a COUNTRY that includes all the countries. And within it is a City that contains all the cities. And within it is a HOUSE that contains all other houses. And within it is a PERSON who contains all other persons. And that person is LAUGHING!!!)

So the wise man took his money and went to the kingdom. When he got there, he saw that

everyone was playing games. And he learned the HUMOR of the place: LIES from beginning to end. Their JOKES consisted of confusing and misleading each other in their business dealings. And bribing each other in their business dealings. And bribing and corrupting the <u>courts</u>. The wise man went from court to court, each one higher than the next, and in every court he saw their way was bribery, and they betrayed even those who bribed them: one day, they would take a man's money; the next day they would not know him from Adam.

FINALLY, after going through EVERY COURT IN THE LAND, up to the highest, the wise man came to stand before the king himself. And in the presence of the king, he said: "Over WHOM are you king? For the country is full of LIES from the beginning to the end, and there is not an ounce of truth." And he went on to describe all the acts of deceit he had encountered in the country. And when the king (who was behind a curtain) heard his words, he inched his ear to the curtain to listen more carefully. He was astonished that there should be such a man who knew all the lies of his kingdom. And the officials of the kingdom who heard the man grew very angry at him, but he went right on talking and describing all the lies of the

country. "And it would be fitting," he said, "to
say that the king, too, is LIKE THEM, that he
is a lover of LIES like the REST OF THE KING-
DOM . . . but I stop short of this: I see that
you are a MAN of TRUTH, and because of this,
you stay far away from them because you can't
bear the lies of the kingdom." And he started
to EXULT better the PRAISES of the king, and
the king, because he was such a HUMBLE man,
whose very greatness was in his humility—and
because it is the way of a humble man to grow
<u>smaller</u> and <u>humbler</u> the more you praise him;
and because of the GREAT INTENSITY of the praise
which the wise man rained upon the king—the
king grew humbler and smaller until he was
virtually shrunk down to nothing. And he could
not endure it any longer, and he thrust aside
the curtain to look at the wise man: who was
HE who knew so much?

And his face was seen. And the wise man saw
him. And he took his picture back to the king.

All of that 120 years before Kafka! But more to the point,
forty years before the invention of chemical photography.
For what else was one to make of that stunning last stanza,
"And his face was seen. And the wise man saw him. And he
took his picture back to the king." (How else would he have
done it other than by *taking his picture*?)

Actually, including the story here got me to wondering about all of that all over again, and I sought out other translations, in particular Joachim Neugroschel's in his authoritative *Great Works of Jewish Fantasy and the Occult* (1976; pp. 265–67), and Neugroschel has it as follows:

> The wise man saw his face and painted his portrait,
> and then he brought the portrait back to the king.

Which I suppose makes more sense. I called up Joel, who in the meantime has mellowed into the Director of Judaic Studies at Tufts (we're still in fond semiregular contact), and he agreed to double back to the original text for me and presently he reported:

> As to your query: as you remembered from ca. 1971–72 (!), the tale itself did indeed say that the wise man painted (in Yiddish: *hot gemolt*) a portrait of the king, and took it back to the (first) king. Arnold Band, in his translation Nahman of Bratslav: The Tales (Paulist Press, 1978), renders it similarly: "The wise man saw him, and painted his portrait, and he brought it to the king" (p. 119).

So, oh well, there goes that frisson. Still, I like Joel's version better and not just for its photographic misprision, I love its jaunty rhythms and I love the tale itself, all that stuff about knowing the nature of the kingdom through the HUMOR of the kingdom, and the nature of the king-

dom being lies all lies, and yet the (second) king's being a MAN OF TRUTH who stays far away from the lies of the kingdom since he can't stand all the lies (a neat twist, that, on the causal polarities implied in the Lurianic *Tsimtsum*). I think Shimmel Zohar would have loved it, too, and who knows, maybe he did (Bratslav not being *that* far away from the photographer's native Lithuania).

I wanted to include a portrait of Nachman of Bratslav at this point and went spelunking for same on Google but was informed that no such authenticated image existed. Except that then, suddenly, there appeared to be one after all. Digging a bit deeper, I came upon an article in the VIN-news of March 29, 2009 (https://vinnews.com/2009/03/29/jerusalem-man-draws-photo-of-reb-nachman-of-bratslav-ztl-after-claims-of-dream/) which reported that a Jerusalem man "by the name Avraham Chaim Biton claimed that Rabbi Nachman appeared in one of his dreams and told him to draw a picture of him," which Biton proceeded to do. Nachman was the founder of the Breslov Hasidic Dynasty, and when the ten current Breslover rabbis in Jerusalem were shown the portrait, five accepted it as authentic, two rejected such authentication, and three had yet to be shown the painting as of the time of publication. Make of all that what you will, but here it is:

Unofficial rendering of Rabbi Nachman of Bratslav by the untutored artist Avraham Chaim Biton

VI

32 {pg. 61} Wait, what? *Sixteen hundred pardons!?* Seriously? What the—?

33 {pg. 64} The exquisitely wise and gentle Alastair Reid, translator of both Neruda and Borges and a fine poet

and reporter in his own right, was one of my most precious mentors during my early days at the *New Yorker*, and a dear friend clear through his passing in 2014. For some reason though (maybe premonition, but that's a whole other, very annoying and very silly story), he published this piece in the *New York Review of Books* in November 1980 (it was subsequently included in several of his own and other people's collections):

Alastair Reid

In Memoriam, Amada

Judas Roquín told me this story, on the veranda of his mildewed house in Cahuita. Years have passed and I may have altered some details. I cannot be sure.

In 1933, the young Brazilian poet Baltasar Melo published a book of poems, *Brasil Encarnado*, which stirred up such an outrage that Melo, forewarned

by powerful friends, chose to flee the country. The poems were extravagant, unbridled even, in their manner, and applied a running sexual metaphor to Brazilian life; but it was one section, "Perversions," in which Melo characterized three prominent public figures as sexual grotesques, that made his exile inevitable. Friends hid him until he could board a freighter from Recife, under cover of darkness and an assumed name, bound for Panama. With the ample royalties from his book, he was able to buy an estancia on the Caribbean coast of Costa Rica, not far from where Roquín lived. The two of them met inevitably, though they did not exactly become friends.

Already vain and arrogant by nature, Melo became insufferable with success and the additional aura of notorious exile. He used his fame mainly to entice women with literary pretensions, some of them the wives of high officials. In Brazil, however, he remained something of a luminary to the young, and his flight added a certain allure to his reputation, to such a point that two young Bahian poets who worked as reporters on the newspaper *Folha da Tarde* took a leave of absence to interview him in his chosen exile. They traveled to Costa Rica mostly by bus, taking over a month to reach San José, the capital. Melo's retreat was a further day's journey, and they had to cover the last eleven kilometers on foot. Arriving at evening, they announced them-

selves to the housekeeper. Melo, already half-drunk, was upstairs, entertaining the daughter of a campesino, who countenanced the liaison for the sake of his fields. Melo, unfortunately, chose to be outraged, and shouted, in a voice loud enough for the waiting poets to hear, "Tell those compatriots of mine that Brazil kept my poems and rejected me. Poetic justice demands that they return home and wait there for my next book." For the two frustrated pilgrims, the journey back to Bahia was nothing short of nightmare.

The following autumn, a letter arrived in Cahuita for Baltasar Melo from a young Bahian girl, Amada da Bonavista, confessing shyly that her reading of *Brasil Encarnado* had altered her resolve to enter a convent, and asking for the poet's guidance. Flattered, titillated, he answered with a letter full of suggestive warmth. In response to a further letter from her, he made so bold as to ask for her likeness, and received in return the photograph of an irresistible beauty. Over the course of a whole year, their correspondence grew increasingly more erotic until, on impulse, Melo had his agent send her a steamship ticket from Bahia to Panama, where he proposed to meet her. Time passed, trying his patience; and then a letter arrived, addressed in an unfamiliar hand, from an aunt of Amada's. She had contracted meningitis, and was in a critical condition. Not long after, the campesino's daughter

brought another envelope with a Bahia postmark. It contained the steamship ticket, and a newspaper clipping announcing Amada's death.

We do not know if the two poets relished their intricate revenge, for they remain nameless, forgotten. But although it would be hard nowadays to track down an available copy of *Brasil Encarnado*, Baltasar Melo's name crops up in most standard anthologies of modern Brazilian poetry, represented always by the single celebrated poem, "In Memoriam: Amada," which Brazilian schoolchildren still learn by heart. I translate, inadequately of course, the first few lines:

> Body forever in bloom,
> you are the only one
> who never did decay
> go gray, wrinkle, and die
> as all warm others do.
> My life, as it wears away
> owes all its light to you . . .

When Judas had finished, I of course asked him the inevitable question: Did Baltasar Melo ever find out? Did someone tell him? Roquín got up suddenly from the hammock he was sprawled in, and looked out to the white edge of surf, just visible under the rising moon. "Ask me another time," he said. "I haven't decided yet."

34 {pg. 64} To give just one example from the original *Predicting the Past* tome, at full length (and many of the entries do go on and on: *you think my endnotes are something!*), here follows the Somnambulist's commentary on *just one*—Plate 11—of the book's fifty-five plates in all of its authoritatively lavish detail, varying degrees of pertinence, and (shall we say?) not entirely consistent reliability:

PLATE 11
WOMAN HAND-KNITTING A CONDOM

An early sign of the use of condoms appears in cave paintings dating to 11,000 BCE at Grotte des Combarelles in Dordogne, France. Further evidence from the twelfth Egyptian dynasty suggests that men of varying social status wore small sheaths made from oiled animal intestines, refined papyrus cloth, or bladders that covered only the top of the penis. Unfortunately, no hieroglyphic accounts survive on walls to clarify their purpose, and re-

gardless, pictograms are not particularly adept at conveying sexual innuendo. But artifacts found in the tombs of Egyptian nobility include form-fitting penis sheaths, some brightly colored, made of soft animal skins and adorned with fur. Along with these decorative artifacts, tombs were equipped with strap-on penises made from tortoise shell and mother of pearl—ensuring that the tomb's occupants were well prepared for a romp in the netherworld.

Italian anatomist Gabriele Falloppio published the first description of the condom in a book that appeared posthumously in 1564, recommending a piece of tincture-soaked linen, sewn to fit around the penis, to prevent the transmission of syphilis. The disease was pervasive across Europe at the time, and Falloppio was the first to devise this method to prevent contagion. By 1605, Leonardus Lessius mounted a theological argument against condoms, claiming in his tract *De justitia et jure* that using them was immoral—further proof that condoms have always been a touchy subject.

But apart from the matter of morality, another question arises: how were condoms fabricated during their long history? In the 1400s, the Chinese used either lamb intestines or oiled silk paper to make condoms that fit over the glans. Concurrently, the Japanese made them from tortoise shell or animal horn—hard to picture but still preferable to a practice in Europe in the Middle Ages, when some

women attempted to prevent conception by wearing an amulet around their thighs made of the testicles of a weasel.

For the resourceful and well-motivated, a whole host of raw materials eventually became available for making condoms by hand. The intestines of most fish, excluding piranhas, proved to be an excellent source. Pig bladder was sensational—but could never penetrate the Jewish market. Objections to condoms were not strictly limited to the religious; one of Casanova's many paramours moaned that she did not like "ce petit personnage" when it was covered, claiming the condom was meant for the boring or overcautious.

Thomas Malthus' *Essay on the Principle of Population*, published in 1798, pointed out that the food supply, which grows arithmetically, can never keep up with exponential population growth. This book became the basis of a social movement in England known as Malthusianism, which was dedicated to the cause of limiting reproduction. Among other initiatives, it inspired a grassroots effort to distribute instructions among the poor for making condoms from animal intestines. Limited literacy among the underclass meant that instructions were kept simple, with illustrations in some cases. Some saw the potential of starting a cottage business, taking it upon themselves to make and sell condoms to the public. Mrs. Phillips distributed the following

handbill for her business in London, known as the "Machine Warehouse":

> She defies anyone to equal her Goods in England, or any other Country whatsoever; having lately had several large Orders from France, Spain, Portugal, Italy, and other foreign Places. Captains of Ships, and Gentlemen, &c. going abroad, may be supplied with any Quantity of the best Goods on the shortest Notice . . . She likewise has great choice of Skins and Bladders, that Apothecaries, Chemists, Druggists, &c. may be supplied with any Quantity, and of the best sort.

The invention of vulcanized rubber by Charles Goodyear in 1839 introduced an improved material suitable for condom manufacture. The first rubber condoms, sold a decade later, covered only the glans of the penis, but this was just the tip of manufacturing to come. Vulcanization, which made rubber more durable and flexible, became the basis for mass production of condoms—and of course, the origin of the term "rubber." Condom manufacturing and advertising grew, along with the enterprise of mail order condoms. Later, Goodyear and B. F. Goodrich became major players in the manufacture and sale of condoms as well as diaphragms and dildos.

In spite of the availability of rubber condoms,

Handbill for Ladies' Fair 4 ½ x 7¼ in.
A splendid example of how condoms were
discreetly offered for sale to the public

many manufacturers continued the tradition of using animal intestines imported from European butchers. In America, where the subject was broached only reluctantly, those who preferred to make their own condoms from animal intestines gave their local butchers coded lists that only seemed to specify the ingredients for homemade sausages. In the 1840s, birth control advocates in Philadelphia circulated instructions for making condoms, information that

was enthusiastically tested in small towns and rural communities along the eastern seaboard.

Throughout the nineteenth century, knitting was a practical and popular source of domestic entertainment. It was only to be expected that women who made their own garments would experiment with knitting as a way of fashioning condoms. Even wealthy women became expert at knitting in the Victorian era, as confirmed by many photographic portraits. One exemplar of this knitting culture can be found in the image of a *Woman Hand-Knitting a Condom.* In early and mid-nineteenth-century America, the homemade condom amplified an already lengthy list of "woman's work" in rural areas. Women also tried out variations on these homespun versions, enhancing their experiments in sewing and knitting circles, and the hand-knitted condom gradually evolved from this shared knowledge. One could find homemade condoms for sale at ladies fairs and at wool-growers markets throughout the countryside. Later, some conjectured that the wool condom's effectiveness in the nineteenth century may have been due to greater sperm size. But knitted wool condoms, which ultimately proved ineffective as a form of contraception, continued in use for warmth on cold winter nights.

The popularity of skins and rubbers, both commercial and homemade, rose abruptly during the Civil War. By 1862, the Army of the Potomac, led

by General Joseph Hooker, arrived en masse in the nation's capital. Female camp followers, designated "Hooker's Legions" by the Federal Army, plied their trade among them. The Union soldiers visited Lafayette Square to consort with these prostitutes so frequently and copiously that General Hooker made it an official meeting place. He added police to make the area safe and ordered all troops to use their "French Letters." The prostitutes fondly named this red-light district "Hooker's Row," and the term "hooker" has remained popular slang ever since.

Following the Civil War, Congress was pressured to pass an anti-obscenity bill addressing pornography and prostitution. Anthony Comstock, a disgruntled former Union soldier, took it upon himself to launch a personal morality crusade beginning in New York City, then known as the Gomorrah of the West. Comstock's initial provocation occurred when his co-worker at a dry goods store in Manhattan contracted syphilis, which he blamed on an erotic book purchased at a nearby store. Comstock marched over to the shop and purchased a similar book, then returned with a police officer to arrest the proprietor, Charles Conroy. Comstock, called a hero by a local newspaper, basked in the success of his scheme and redoubled his efforts, this time taking a reporter and a police officer with him to St. Anne's Street, where vendors openly sold such "illicit" books. Comstock attracted the attention of the leader of the local

Members' punch card, 2½ x 4 in., New York
Society for the Suppression of Vice.

YMCA, who soon joined forces with him to save young people from obscenity. Together they founded a movement known as the New York Society for the Suppression of Vice.

Comstock understood personally the perils of obscenity for youth. A chronic masturbator well into adult life, he suffered tremendous guilt for submitting to the "Satanic Temptation," as he confessed in his diary. Taking the upper hand, Comstock sought to control in others what he could not control in himself, making a solemn vow to purge sin from the face of the earth. Comstock's campaign attracted the attention of wealthy investors, including industrialists J. P. Morgan and Samuel Colgate. Using their money and influence to lobby Congress, Comstock launched a campaign to "Make America *Moral* Again." Under pressure, Congress promptly enacted bills that would have lasting influence on all aspects of sexuality in America.

Congress intended the Comstock Act of 1873 to target mail order pornography specifically, and designated Comstock a special agent of the U.S. Post Office to enforce it. He used his newly vested authority to arrest anyone sending or receiving "indecent" material through the mail. As a founding member of the New York Society for the Suppression of Vice, Comstock didn't have to answer to anyone, which gave him authority to implement censorship more broadly. The nation soon discovered that Comstock had been given free rein to define a wide swath of activity as indecent or obscene.

The Comstock Act was to condoms what the temperance movement was to liquor: the production, use, sale, or advertising of condoms or any form of birth control was made illegal. Sending or receiving condoms by mail was also illegal. The penalty for being caught talking, writing about, possessing, selling, or producing condoms, or any other form of birth control, could result in a long prison term and a hefty fine.

Comstock and his agents, who had wide discretion in enforcing the act, targeted small proprietors on the margins of society while overlooking more established business owners. In one egregious example, Comstock turned a blind eye to his staunch supporter Samuel Colgate, the millionaire heir of Colgate and Company, who conspicuously promoted Vaseline as a contraceptive and profited handsomely

from its sale. Meanwhile, Colgate continued to serve as the president of the New York Society for the Suppression of Vice—known for its vehement opposition to contraception. Colgate's hypocrisy (and his immunity from prosecution) was called out publicly by one D. M. Bennett, a bookseller who had been arrested by Comstock for selling "obscene material."

Blanket enforcement of the Comstock Act undermined a thriving mail order business and poked a hole in condom sales. But pioneering feminists defied Comstock. The right to vote was just one of their causes: birth control and disease prevention were also high on their agenda. On the frontlines of this campaign was Dr. Sarah Chase, a graduate of the Cleveland Homeopathic College, who moved to Manhattan in 1874 and lectured on physiology and sex education to men's and women's groups in churches and meeting halls. At the conclusion of her lectures, she openly sold birth control measures. By 1878 Comstock arranged her entrapment personally by visiting her house for a purchase. Although Chase was arrested at least five times by Comstock and his morality squad, no judge or jury would convict her. Despite laws enacted by Congress, those who sold birth control measures were often tolerated by the justice system.

Widespread loathing of Comstock himself may have encouraged leniency toward birth control

vendors. Scathing editorials and cartoons referred to him as "Comstock the Laughing Stock," and his rotund belly, prominent white mustache, and overgrown muttonchops featured frequently in caricatures. One cartoon, "The Temptation of St. Anthony," showed the portly Comstock dressed in priestly robes, kneeling in trepidation and pointing an accusatory finger at a store window displaying corseted mannequins and ladies stockings. Referred to by liberals as "a peripatetic conservator of morals," he scoured the streets of New York for violators of the Comstock Act. The playwright George Bernard Shaw characterized Comstock's crusade as the inability to distinguish between art and smut. This was, in Shaw's opinion, a national trait: "Europe likes to hear of such things," Shaw said. "It confirms the deep-seated conviction of the old world that America is a provincial place, a second-rate country town civilization after all."

By 1877, Comstock had largely shut down the obscenity trade, but he still made arrests as required by his financial backers, who supported the society's annual $10,000 budget. He received monetary incentives directly for such arrests—he and his squad kept fiftypercent of the fines assessed. Comstock widened his net to include medical books with images of the unclothed body as well as art books that contained nude figure studies or portraits or classical statues. One can only assume that he

would have arrested Adam and Eve if their fig leaves were askew. He arrested his arch nemesis Bennett for possessing a scientific essay about the propagation of marsupials, as animal procreation could also be considered obscene. Had he convened a kangaroo court to bring charges against the marsupials directly, he would have succeeded in reinstating the medieval practice of prosecuting animals. Were the birds and the bees next on the docket?

Ezra Heywood, an activist and advocate of equal rights for women, referred to Comstock's tactics as "the spirit that lighted the fires of the Inquisition." Soon after, Heywood was arrested and sentenced to thirteen months of hard labor for flaccid puns in his essay "Cupid's Yokes," where he called Comstock a "religio-monomaniac." Heywood also excoriated Comstock's crusade against the press: "He is chiefly known through his efforts to suppress newspapers and imprison editors disposed to discuss the Social Question." Indeed, Comstock boasted, "There were four publishers on the 2nd of last March; today three of these are in their graves, and it is charged by their friends that I worried them to death." Eventually Heywood received a pardon from President Hayes, who agreed with judges that Comstock had gone too far.

Comstock's unfettered morality campaign

actually had an inverse effect, stimulating a thriving underground economy for small rubber and skin condoms. The process of making condoms was relatively simple and highly profitable, requiring little investment. Outside of New York, small manufacturers continued to take the legal risk of producing and selling condoms and other contraceptives. Discreet ads, or referring to a condom by some other name—even using Civil War slang such as a cap, a pouch, a male shield, or simply a rubber good—served to avoid prosecution.

Europe was more open about marketing condoms, although they were not officially legal there until the next century. In fact, in the late 1890s Queen Victoria became an unwitting shill when her face was used to adorn the labels of rubber condom packages from many manufacturers.

Julius Schmidt, a German Jew born in 1865, came to New York at the age of seventeen. Impoverished, and hobbled by a severely deformed leg, he almost died of starvation until he found a job cleaning animal intestines at a sausage casing factory. Like sausage makers in Europe, he quickly found an alternate use for leftover casings, and started a business making condoms and peddling his wares in the Tenderloin district—so named by Police Department Captain Alexander S. Williams, who claimed he could eat a better cut of meat thanks

to the bribes he received by ignoring crimes. He was reported to have boasted: "I've had nothing but chuck steak for a long time, and now I'm going to get a little of the tenderloin." Prostitution was among the crimes he routinely overlooked.

Arrested by Comstock in 1890, Schmidt had to walk on crutches to the paddy wagon. Bailed out of jail, he paid a stiff fine but vowed to make a success of his business. He changed his name to Schmid, thinking it would shield him from anti-Semitism that the final "t" might attract. He branched out into condom manufacture, determined to make condoms of the finest quality that would also be affordable for poor Americans. Germany was the world leader in condom manufacture, and Schmid was the first in the U.S. to use the advanced methods that were developed there. The German technique, using glass molds dipped in liquid rubber, produced condoms that were thin, flexible, and seamless. Prior to 1914, Germany had been Europe's number one supplier of condoms to the U.S., but the war put an end to German imports. Schmid stepped into the breach and became the leading American exporter of condoms to the Allies. In 1932 Schmid returned briefly to his native Germany and purchased a state-of-the-art rubber manufacturing plant that he then dismantled, shipping all of the equipment to New Jersey, where he reopened the business. His timing was opportune, because

the persecution of Jewry that would culminate in the Holocaust was already underway. Schmid's enterprise remained a profitable, global business. His leading brands, Sheik and Ramses, were produced until the 1990s.

Despite Comstock's flagrant abuse of office, it took years for progressives to dismantle the Comstock Act, due primarily to his powerful connections in Washington. But judges and juries grew weary of his moralistic courtroom histrionics, typically directed against struggling business owners and manufacturers of condoms—most of them women, Jews, and immigrants. Finally, Supreme Court decisions holding that mail was private, and therefore protected under the First and Fourth Amendments, dealt Comstock a major blow.

Comstock spent his last years in futile pursuit of Margaret Sanger, a progressive advocate for women's rights and birth control, eventually the founder of Planned Parenthood. She had begun her career as a birth control advocate while working as a nurse in New York City. Appalled by the terrible living conditions endured by the poor, she opened a clinic and dispensed birth control and educational advice to desperate women. Sanger, arrested twice for sending reproductive information through the mail, argued in her own defense that the Constitution did not authorize the post office

to sit in judgment on the morality of the printed matter or parcel it was entrusted to deliver. In his final courtroom appearance, Comstock's swan song struck a sour note, as he shouted in court that Sanger had violated the Criminal Code by giving away a copy of her book *Family Limitation*. He died a week later from illness apparently brought on by overwork and overexcitement. He had wielded his tyrannical power from 1873 until his death in 1915, setting the clock back on medical advances and disease prevention by forcing a code of silence on the American sexual psyche.

Condoms, which were still contraband at the beginning of the twentieth century (along with all contraception), are now part of the social fabric. Instructions for making a handmade condom are no longer necessary—to the relief of many. Once wrapped in taboo, the modern condom is available for purchase almost everywhere, in a variety of sizes, textures, and colors. Following a tumultuous history, and a long hard road, the condom has finally met with a happy ending.

So, alright then, any questions?

35 {pg. 64} Another time, Berkman added a third element, beyond "Zohar Studios and the historical imagination" to that formulation regarding the intended objects of his tribute, adding as well "the specific tradition of Jewface,"

which had me diving into Google, which by way of https://
yivo.org/jewface, offered the following elaboration:

> With his fake beard, putty nose, and thick Yiddish
> accent, the "stage Jew" was once a common character
> in vaudeville, part of genre that mocked immigrants
> and minorities in terribly offensive ways. Essentially
> a variant of blackface minstrelsy, the music that
> accompanied these "Jewface" performances was not
> only performed on stage, but was also published as
> colorfully illustrated sheet music so fans could play
> them at home.

Jewface

> Outrageous and offensive by today's standards, these
> "Yiddish" dialect songs sung by these figures exploit-
> ed a variety of unpleasant stereotypes about Jews.
> The sheet music produced for the genre engaged
> some of the same unpleasant stereotypes.
> While the genre was initially created by gentile per-
> formers to make fun of Jewish immigrants, it was

eventually taken over by Jews, who apparently felt that they could do a better job mocking themselves (and rake in good money in the process). Irving Berlin, Fannie Brice, and Sophie Tucker were just a few who wrote and performed these Yiddish-inflected songs.

36 {pg. 64} An impulse, as you will have gathered, that I can relate to. But Berkman's mention sent me back to Nabokov's novel itself, and I ended up being struck by an influence considerably more profound than the merely formal that *Pale Fire* may have exercised (even if only subliminally) on Berkman's own imagination. For read in this context, the first stanza of the character Slade's poem, the founding occasion for Nabokov's whole story, seems to all but anticipate Berkman's entire process in relationship to Zohar:

> I was the shadow of the waxwing slain
> By the false azure of the window pane
> I was the smudge of ashen fluff—and I
> Lived on, flew on, in the reflected sky.
> And from the inside, too, I'd duplicate
> Myself, my lamp, an apple on a plate:
> Uncurtaining the night, I'd let dark glass
> Hang all the furniture above the grass.
> And how delightful when a fall of snow
> Covered my glimpse of lawn and reached up so
> As to make chair and bed exactly stand
> Upon the snow, out in that crystal land.

Above: Luis Buñuel's *Simon of the Desert*
Left: Zohar's *The Last Refuge*

37 {pg. 66}: Sounds like a quintessential case of *accidié* to me, that classic affliction of the early Christian desert hermits, a surmise further buttressed by the fact that it was around this very time that Berkman appears to have been restaging that late figure of the Six Victorian Gentlemen, latter-day heirs to St. Simeon Stylites, wending their way about the top of that desert pillar.

For a full DSM-style symptomology of that desert affliction, there's probably no source better than Helen Waddell's translation of *De Spirtu Acediae* by John Cassian (360–435 CE) (included in Waddell's 1936 book *The Desert Fathers*):

Our sixth contending is with that which the Greeks call ἀκηδία, and which we may describe as tedium or perturbation of heart . . . It is akin to dejection and especially felt by wandering monks and solitaries, a persistent and obnoxious enemy to such as dwell in the desert, disturbing the monk especially about midday, like a fever mounting at a regular time, and bringing its highest tide of inflammation at definite accustomed hours to the sick

soul. And so some of the Fathers declare it to be the demon of noontide which is spoken of in the xcth Psalm Ps 90:6 LXX. When this besieges the unhappy mind, it begets aversion from the place, boredom with one's cell, and scorn and contempt for one's brethren, whether they be dwelling with one or some way off, as careless and unspiritually minded persons. Also, towards any work that may be done within the enclosure of our own lair, we become listless and inert. It will not suffer us to stay in our cell, or to attend to our reading: we lament that in all this while, living in the same spot, we have made no progress, we sigh and complain that bereft of sympathetic fellowship we have no spiritual fruit; and bewail ourselves as empty of all spiritual profit, abiding vacant and useless in this place; and we that could guide others and be of value to multitudes have edified no man, enriched no man with our precept and example. We praise other and far distant monasteries, describing them as more helpful to one's progress, more congenial to one's soul's health. We paint the fellowship of the brethren there, its suavity, its richness in spiritual conversation, contrasting it with the harshness of all that is at hand, where not only is there no edification to be had from any of the brethren who dwell here, but where one cannot even procure one's victuals without enormous toil. Finally we conclude that there is not health for us so long as we stay in this place, short of abandoning the cell wherein to tarry further will be only to perish with it, and betaking ourselves elsewhere as quickly as possible.

Towards eleven o'clock or midday it induces such lassitude of body and craving for food, as one might feel after the exhaustion of a long journey and hard toil, or the postponing of a meal throughout a two or three days fast. Finally one gazes anxiously here and there, and

sighs that no brother of any description is to be seen approaching: one is for ever in and out of one's cell, gazing at the sun as though it were tarrying to its setting: one's mind is in an irrational confusion, like the earth befogged in a mist, one is slothful and vacant in every spiritual activity, and no remedy, it seems, can be found for this state of siege than a visit from some brother, or the solace of sleep. Finally our malady suggests that in common courtesy one should salute the brethren, and visit the sick, near or far. It dictates such offices of duty and piety as to seek out this relative or that, and make haste to visit them; or there is that religious and devout lady, destitute of any support from her family, whom it is a pious act to visit now and then and supply in holy wise with necessary comforts, neglected and despised as she is by her own relations: far better to bestow one's pious labour upon these than sit without benefit or profit in one's cell.

For his own part, Berkman insists that the inspiration for his pillar-standers was not so much any Desert Father but rather Mark Twain, in his *Connecticut Yankee in King Arthur's Court,* where the Yankee in question wanders the Valley of the Hermits and encounters a fellow who lived on a pillar and continually bent over at the waist in the midst of his prayers, whereupon the Yankee suggested hitching the fellow up to a sewing machine so as to manufacture linen shirts. Melville, in another nineteenth-century text dear to Berkman, likened the sailors who stood watch atop the mastheads to St. Stylites, going on to note how the good saint had died at his post, unmoved by the elements.

38 {pg. 67} To give but one further example of the good

professor's philological-historiographic speculative stylings, here he is discussing Plate 3, a photograph of Zohar's own Plate Box (see page 33):

> History is cluttered with the detritus of obsolete technologies. Assuming the species persists, humans may no longer have access to the computers necessary to view digital images produced over the last fifty years. A glass plate, which can be viewed by the naked eye, could make archival retrieval possible thousands of years into the future (even in a post-apocalyptic world). Any intelligent life form (or artificial intelligence) stumbling upon a glass plate photograph would at the very least be able to see the image directly—assuming visual perception is among its attributes. Glass plate images may perhaps outlast their digital counterparts, but we can predict an end to their life cycle as well. After thousands of years, the forces of nature will reduce the glass plate back into grains of sand. The unbroken cycle will be complete, and with a grain of luck, that sand will be used to fill an hourglass.

Speaking of obsolete technologies, I realize here how, now, as we begin to circle down toward the final pages of this account, I have thus far given short shrift to a remarkable section of *Predicting the Past* (coming near the end of that massive tome as well, as it happens): a whole chapter given over to the elucidation of several ingeniously

contrived optical instruments, many of them innovations based on the centuries-old camera obscura, the device by way of which artists and architects and engineers of all sorts could project images of the actual world through a pinhole lens into a darkened space, whereupon they could trace the upside-down and left-right-reversed projection onto any sort of flat surface. (David Hockney has a lot to say about the surprising extent of the usage by artists of cameras obscura and such earlier antecedents as convex mirrors, going all the way back to the fifteenth century—see his delightfully provocative manifesto from 2001, expanded in 2006, *Secret Knowledge: Rediscovering the Lost Techniques of the Old Masters*).

For his part, Zohar's sly innovations included a camera obscura tent disguised as an elegantly demure (though hardly petite) bourgeois lady, albeit with something of a pinhead housing the camera's secret periscope. And a children's version of same.

Obscura Object *A Child's Obscura*

What, I asked Berkman, near the end of our conferences, had been the deal with those?

"Ah, ummm," Berkman hesitated.

I mean, they were Zohar's inventions, right? And the texts were the Professor's?

"Ahhhh." Berkman actually blushed, as if, after all of that, he had somehow finally been found out. "Actually," he confessed, "well, yes, the texts were indeed the Professor's. But the devices . . . Well, the thing of it is, umm, remember that notebook of Zohar's that we found in the false bottom of the trunk?"

Yeah: the baby possum and all that.

"Yeah, that one, but the thing of it is that if you turned that notebook upside down, there was a whole other section at the back consisting largely of charts and diagrams and descriptions, *in reverse handwriting*, in which Zohar laid out the basis for a whole series of novel variations on the camera obscura and other such devices. Only Finkel had just begun translating those, leaving hints on my answering machine, and then, of course, he died and the notebook itself was lost and I had to reconstruct the inventions from memory. But I can't draw—or rather, maybe I should clarify that I prefer not to, out of respect for the photographic—so in any case I had to find an artist who could provide an approximation based on my memory of the sketches."

Kind of like a police composite artist?

"*Exactly!*" Berkman brightened. "Only this guy—his name was Jakub, I forget his last name, his day job was as one of those court sketch artists, and I met him when I

had to go to court for jury duty—remember the time I told you about, where I thought my Dundrearies were going to get me disqualified but they didn't? Anyway, I met this guy in the hallway during a break, and incidentally, he was remarkable in his own way, he only had one arm . . . Which reminds me of the time I was driving Ricky Jay home and near the freeway entrance there was a one-armed juggler busking away, and this so tickled Ricky that he gave me twenty dollars to pass along to him, and the guy managed to grab the bill between tosses, without stopping! Ricky was in heaven."

Wait, but so you don't draw out of respect for photography, but you don't mind having someone else draw for you?

"Yeah, it's kind of like Orthodox Jewish families who retain a *shabbos goy* they can call on if a light needs to be turned on or off during the sabbath, any sort of thing that is otherwise forbidden—that kind of thing. Anyway, this court sketch artist's left arm was missing below the elbow, but somehow he steadied the paper with his elbow-nub and it seemed to work for him. And he agreed to give my proposal a try, we did the drawings on coffee-smeared paper to give his approximations an antique look, as in the original notebook, and those became the reference drawings, which I in turn drew on to create the photographs."

Funny thing about that particular invention, because the contemporary photographer Abelardo Morell, also a huge fan of cameras obscura, independently came up with a very similar device, also a portable tent, only in his case he took it with him all over the world and would set it up, aim it at

Abelardo Morell's tent method

some notable vista (the Giverny gardens, the Golden Gate Bridge, the Grand Canyon, or, say, the Baptistry in Florence where the Renaissance master Brunelleschi had made his own breakthroughs in the depiction of perspective back in the 1430s), and in his case he would climb inside the tent, seal the drape, focus the luminous projection *onto the ground itself* and then photograph *that* image (the Baptistry, for example, projected onto the dappled pavement before it).

Berkman, for his part, went on to describe how he and Jakub had managed to retro-engineer several of Zohar's other inventions, for example a *Strap-on Obscura*:

And a *Surveillance Obscura*:

And even a *Disposable Obscura* (the granddaddy, I suppose of the Instamatic):

The detritus, indeed, of obsolete technologies.

VII

39 {pg. 71} And maybe here, in closing, is the time to hazard a moment's thought on the phenomenology of footnotes themselves. I once read somewhere how Freud, for his part, once asserted that footnotes serve the scholar as a way of signaling the presence of something large and pendulous down under.

But could that be right? Not whether the assertion is true (an entirely separate question, which we might as well bracket for our purposes here) but rather whether my memory may simply be deceiving me (in a classically Freudian manner) with that possibly phantom recollection? Naturally, in order to try to settle the matter, I had recourse to the net, but the problem when you type "Freud" and "footnote" and "pendulous" into Google is that it turns out that some guy has actually compiled a scholary study entitled *Freud's Footnotes* (naturally, of course: some scholar would have had to have gotten around to doing that), such that the first several pages of links turn out to exclusively reference that essential manual—usually with the word "pendulous" simply crossed out.

So no luck there. But then I remembered how years ago I'd savored a truly seminal volume on the history of footnotes themselves, my friend the Princeton historian Anthony Grafton's magisterial treatise, *The Footnote: A Curious History*—could that be, I wondered, where I'd first come upon the anecdote? So I grabbed that volume off my alphabetically arrayed shelf ("It's not hoarding if it's books,"

I kept intoning my reassuring mantra), tore through to its index and drilled for "Freud," only to discover that, surprisingly, there was no such listing at all. Hmmm. But the sheer heft of the thing in my hands brought back such enchanted memories that I turned back to the book's preface, where in his very first paragraph Grafton observes:

> Many books offer footnotes to history: they tell marginal stories, reconstruct minor battles, or describe curious individuals. So far as I know, however, no one has dedicated a book to the history of the footnotes that actually appear in the margins of modern historical works. Yet footnotes matter to historians. They are the humanist's rough equivalent of the scientist's report on data: they offer the empirical support for stories told and arguments presented. Without them, historical theses can be admired or resented, but they cannot be verified or disproved. As a basic professional and intellectual practice, they deserve the same sort of scrutiny that laboratory notebooks and scientific articles have long received from historians of science.

And so forth. I cut ahead to the first chapter, "Footnotes: The Origin of the Species," where Grafton launches out, "In the eighteenth century, the historical footnote was a high form of literary art." Whereupon he proceeds to celebrate those of Edward Gibbon, author of course of *The History of the Decline and Fall of the Roman Empire,* the delicious

Grafton Gibbon

"irreverence" of whose footnotes went far "to amuse his friends and enrage his enemies." A characterization which elicits Grafton's own footnote number 1, already packed with detailed confirmatory citations. Grafton then goes on to sample some of his own favorite sly Gibbonories, such as:

> "The duty of an historian," remarks Gibbon in his ostensibly earnest inquiry into the miracles of the primitive church, "does not call upon him to interpose his private judgment in this nice and important controversy."

(or)

> "The learned Origen" and a few others, so Gibbon explains in his analysis of the ability of the early Christians to remain chaste, "judged it the most prudent to disarm the predator." Only the footnote

makes it clear that the theologian had avoided temptation by the drastic means of castrating himself—and reveals how Gibbon viewed this operation: "As it was his general practice to allegorize scripture; it seems unfortunate that, in this instance only, he should have adopted the literal sense."

A few pages further on, still anatomizing the special appeal of Gibbon, Grafton opines as to how,

> Though his footnotes were not yet Romantic, they had all the romance high style can provide. Their "instructive abundance" attracted the praise of the brilliant nineteenth-century classical scholar Jacob Bernays, as well as that of his brother, the Germanist Michael Bernays, whose pioneering essay on the history of the footnote still affords more information and insights than most of its competitors.

That being the end of a paragraph, just four pages into the chapter, to which Grafton already appends footnote number 14. A footnote whose own slyly lilting erudition mirrors that of Grafton's hero, to wit:

> The phrase "*lehrreiche Fulle*" is Jacob Bernays', as quoted with approval by his brother Michael Bernays. The relationship between the two brothers deserves a study. Jacob mourned his brother as

dead when he converted to Christianity, but Michael nonetheless emulated Jacob's analysis of the manuscript tradition of Lucretius in his own genealogical treatment of the editions of Goethe. {Whereupon Grafton interposes five detailed lines of specific amplificatory citations, before concluding} So far as I know, the third brother, Freud's father-in-law Berman, did not venture any opinion on Gibbon's footnotes.

That last sentence threw me for a bit of a loop, or actually two loops. Because, first of all, I thought, Wait a second, why wasn't that "Freud" reference included in the book's index, and did that in turn mean that the Freud-pendulous anecdote might in turn still lie hidden somewhere else in Grafton's volume? But more to the point, I knew all about Berman Bernays by way of *his* granddaughter, Judith Bernays (Heller), a close friend of my own grandmother Lilly Toch (and housemate after the death of her husband, the composer Ernst Toch), who was, as she, Judith, never tired of explaining to us, "twice the niece of Freud." Which is to say that Freud and his sister had married a brother and sister, such that Judith was the daughter of Sigmund Freud's sister Anna and Freud's wife Martha Bernays' brother Eli. (For good measure it is now thought highly probable that in 1900, right around the time he published *The Interpretation of Dreams*, Freud had an affair with the youngest sister of Anna and Eli, Minna, who may consequently have needed an abortion but then went on to live as a spinster with the

Freud family for decades thereafter—but that too is a whole other story. For more on which, though, see the piece on Peter Swales and his research in the *New York Times* of November 22, 1981.)

Judith's own kid brother, as some of you may already have surmised, was Edward Bernays, the notoriously famous founder, in the years after the First World War, of the entire corporate public relations (focus group-convening, consumer taste-molding, public opinion-swaying) industry in the United States, or so anyway he liked to fancy himself—and many, including Adam Curtis in his BBC documentary series *The Century of the Self,* seemed to concur). I myself came to realize this when, at Judith's behest, I would occasionally pay calls on him in his elegantly burnished Lowell Street, Cambridge manse, and he would entertain me with tales of how, among other triumphs, he had virtually singlehandedly convinced Americans (at the behest of the pork industry) that bacon was a virtual breakfast essential (oy!); that cigarettes granted "torches of freedom" to young women of the nineteen-twenties who'd never much fancied tobacco; and that in the wake of Prohibition, beer (as opposed to hard drinks) constituted the essence of moderation and even provided "a vaccination against intemperance." He was known as "the father of spin," would come to be crowned one of *Life* magazine's "100 Most Influential Americans of the Twentieth Century," and from what I could tell, through the end of his days was altogether satisfied with his capacious good works.

Judith, on the other hand, was made of grimmer stuff.

She brooked no guff, or so it seemed to me and my siblings during our younger years when on visits to our grandmother's, perhaps in all fairness, we gave nothing but. She was a dark and brooding presence, short and stooped and shuffling, and the spitting image of her uncle, with the same hard-set battle-ax jaw covered over with the same fine pelt of blanched whiskers, before which we kids used to marvel in stupefaction. But over the years she grew on me, or maybe I just grew up. ("When I was a boy of fourteen, my father was so ignorant I could hardly stand to have the old man around. But when I got to be twenty-one, I was astonished at how much he had learned in just seven years."—Mark Twain). By the time *I* was twenty-one, I was deep into college at Santa Cruz, and what with the death of my grandmother back in Santa Monica, Judith had returned to her prior abode in Berkeley, so I would go up to visit with her every few weeks. I used to revel in her tales of her visits back to Vienna and her stays with the Freud family, and then her years in London when she gravitated around the Bloomsbury circle, contributing translations to the Hogarth Press's twenty-four-volume edition of the complete works of Freud, and I used to regale her in turn with my own growing conviction that, his avowed and flinty skepticism notwithstanding, her uncle (subject of my junior thesis) had been, perhaps even

Judith Bernays Heller
in younger days

unbeknownst to himself, some sort of latter-day secular Kabbalist (see note 14, pg 98 above). Judith was neither convinced nor, I suspect, remotely amused.

I spent the summer of 1973 in Berkeley in a somewhat hapless attempt at a crash German language course—hapless in part because I'm just not that gifted in languages; and especially so because I still suffered from something of an aversion to German in particular since it was the language that my parents, who basically got along fine, would revert to whenever they took to arguing, under the mistaken impression that we kids couldn't tell they were bickering because they were doing so in a language we couldn't understand but therefore grew positively to cringe at; but mainly because that was the summer of the Watergate hearings, and like everyone else, we would-be German-immersers instead spent the entire day glued to our TV sets taking the live telecasts all in, and then most of the evening watching the rebroadcasts of the same hearings all over again, aping all the best lines and mimicking the sputtering furrowings of Senator Erwin's fantastically expressive eyebrows.

But every few days, during hearing recesses, I'd head over to Judith's. She was quite frail by then and had gone completely blind, and so we agreed that I would read to her, and she wanted to sample the then-new Quentin Bell biography of Virginia Woolf, one of the first of what would soon become a flood of such literary pathographies. As rapidly became clear, Bell's take on things was quite salacious, and as I continued reading, I often glanced ahead with considerable trepidation at what scurrilous horrors

lay just up the facing page. I needn't have worried. One day, I gazed ahead and gulped at the upcoming prospect of a thoroughly lurid account of some of Lytton Strachey's extracurricular activities, but I steadied my voice and just kept on reading. No sooner had we forded the passage in question that Judith interrupted me, grousing, "Nonsense: Lytton didn't care for that boy one fig: who he really had the hots for that year was a randy Romanian sailor!"

Those were some of my last visits with Judith. In September I returned to Santa Cruz, where one day I received a manila envelope in the mail, addressed in oversize shivery letters. Judith was sending me the family's print of the famous photo of Freud that graces the cover of Ernest Jones' biography of him. "This is my uncle," she wrote in a note in that same shivery hand, "during his last year, in London, reviewing the page proofs for his last book, <u>Moses and Monotheism</u>. And this is just to reiterate to you that my uncle was no mystic. Nonetheless: love, Judith." And she herself passed a few weeks after that.

Sigmund Freud, 1939

Anyway, where was I? Oh yeah—whether or not Judith's uncle ever actually said that thing about footnotes. I was coming up dry in my further investigations, but I was not entirely without recourse. So I picked up the phone and called Tony Grafton and outlined the entire situation, recounted some of my tales about Judith, complimented him on his footnote book though complaining about the evident inadequacies of its index, and finally just sprang the question point blank: had he, as perhaps the world's leading authority on footnotes, himself included that comment of Freud's about the large pendulous down under anywhere in his book or for that matter ever heard tell of it?

Grafton laughed and confessed that no, he hadn't included the anecdote in his book and for that matter had never before now heard it, but it sure sounded like Freud to him, and even if Freud hadn't actually said it, he surely should have, and even if he didn't that he, Grafton, wouldn't be the one to call out the footnote police on me if I decided to include it.

So: who knows?

All I know is that somewhere there just has to be an end to all these digressions, and it might as well be here.

§

Except that, oh yeah! Speaking of pendulous things down under, do yourselves a favor and go look up "Willy Warmers" in Wikipedia.

Just saying.

ACKNOWLEDGMENTS

For starters, of course, the author would like to extend his most profound gratitude, or something anyway, to Stephen Berkman, without whose remarkable exertions over several decades the entire saga of Shimmel Zohar's extraordinary legacy might never have come to light, and more to the point (though somewhat less convolutedly so), neither would this current volume. Stephen's ever-stretched forbearance at my ever-stretching persistence across all our conversations wasn't even the half of it: in addition, his brimming generosity in sanctioning the reproduction of all the Zohar works in this volume and his boundless energy in helping me secure the rest of the book's images proved key to the realization of the entire project. I express my appreciation to him and urge this book's readers to do likewise by seeking out Berkman's own magnum opus on Zohar's life, work, and times, *Predicting the Past*, also available from the good folks at Hat & Beard Press of Los Angeles, California, purveyors as well of all sorts of other strange and sumptuous fare (do check out their catalog).

Speaking of which, secondly, I want to thank the near pathologically indefatigable magus behind the entire Hat & Beard operation, the distinctively hirsute J.C. Gabel, for allowing (nay, encouraging!) me to raid my Afterword to that *Predicting the Past* volume as the basis for this one, and for allowing (nay, encouraging) my digressive delirium

of ensuing footnotes to grow ever more loopily extensive and just plain loopy. Brave man, and a bit of a nut himself.

And for that matter, further appreciation as well to the sterling editor for this effort, Susan Green (great to be working with her again!). I also want to acknowledge Jeanine Tangen for her countless contributions to both this book and the original tome, *Predicting the Past*, and this book's designer, the formidable and formidably chill Sabrina Che. They all made it feel easy, which I know it wasn't.

As it happens, this volume was among the first in a new series being brought out under the purview of Hat & Beard's new not-for-profit division (see indefatigable, above) and as such was allowed to raise seed funds from a range of patrons whom in this specific case included Bella Meyer, Gerry Ohrstrom, Arlene and Milton D. Berkman, John Hastings, Stuart Cornfeld, New York Foundation of the Arts, and the Morton H. Meyerson Family Foundation. Without their lavish contributions, this book might never have come to be, so all credit goes to them. (Though that doesn't mean you should blame them: blame me.)

A particular word here about Stuart Cornfeld, a dear

friend of mine since all the way back in high school (he too having been among the company of hapless nerds circling about the bodacious Miss Krefeld from footnote 22, though his own finely turned nose never brooked any compunctions whatsoever). He grew up to be a prodigious Hollywood producer, a role in which he proved (quite unusually for the breed) to be thoroughly well beloved by just about everyone he worked with, in part because he was just so damn funny and fun to be around. (Not that he was any sort of Pollyanthony: his humor was perenially aslant and his asides deliciously grim, though his sheer delight at the world somehow kept peering through, sovereign and undimmed.)

Then, uncannily for me, about a decade ago, he fell victim to exactly the same extremely rare cancer of the eye that had afflicted my other dear friend, the neurologist Oliver Sacks (the subject of my last book) a few years earlier. As with Sacks, except for the loss of vision in that one eye, he seemed to recover completely—given this second chance, Stuart, for his part, decided to pull back from the frenzy of his producing duties and to relocate to New York, where he became something of a *boulevardier* and *flaneur* about town (a wonderful blessing for me in that it allowed us time to reconnect across a regular series of lunches and other such gallivants)—except that then, exactly as with Oliver, precisely seven years afterwards, the cancer came resurging back, this time, more ominously, in his liver.

There then followed an extended roundelay of experimental therapies (jaunty as ever, Stuart was clearly a favorite

of the doctors and the nurses, all of whom seemed to vie in steering him into their respective programs), from out of which he'd regularly emerge with wry communiques ("I have gained a tremendous amount of respect for guinea pigs." "This Coronavirus is throwing a major wrench in my plans to die of a very rare disease. Now I'm faced with the prospect of simply being victim 9,017 of 87,000 in NYC...very disappointing." "My energy continues to ebb primarily due to the metastasis to my lungs. There are times when I get winded and assume I've contracted COVID-19. But the panic subsides when I realize it's probably just the cancer. Sort of a cloudy silver lining.") He'd get released from time to time and we'd meet again for lunch and he never once evinced the slightest self-pity. On the contrary, on one of our last outings, to the Hungarian Pastry Shop up near Columbia University, he told me how early on, not long after college, he'd come to realize that all he'd ever really want from life was the opportunity to spend as much of it as possible in the company of very smart and very funny people, an ambition he said he felt he'd been blessed, by and large, to have attained: in response I told him that he'd had a leg up in that regard, since he got to wake up every morning in the company of one of the slyest, smartest, wittiest, most generous people around: his own self. At which point, typically, he found some very funny and sly way of deflating the compliment (I wish I could remember the exact phrasing involved). We'd had another lunch date planned, but he had to call it off: he was back in Philadelphia, getting infused with further novel concoctions. "The results of this new trial

have been inconclusive," he wrote. "My doctors have been introducing words like 'hospice' and 'palliative' into our conversations. A welcome change from terms like 'minor discomfort' and 'the Chinese are very optimistic about this potential breakthrough.'" That was the last time I heard from him: he passed a few days later.

Except that a few months after that, completely unexpectedly, I got a registered letter from his estate's lawyers informing me that he had left me $500 in his will, with instructions that I use the money to treat myself to the last lunch he'd whelped out on there at the end. Instead, I applied the $500 to this Zohar project about which he and I had often conferred. A much better use of the funds, after all, in that it will now allow me to dine out on the story, over and over again, for years to come.

The late Ricky Jay, to whom this book is lovingly dedicated, would have enjoyed the foregoing digression about Stuart. For one thing, they too were dear pals, but more to the point Ricky was both a past master and a prime connoisseur of the digressive arts. For years and years, we used to trade them, trying each other's patience, though when it came to Ricky, there was never really any trial involved. His digressions were so erudite and zanily arcane, and delivered with such deliciously cadenced panache, that they almost always transcended the occasions of their spawning. I've written about Ricky at some length elsewhere (see my elegy at the McSweeney's website, recapitulated on my own) but what I wanted to add here was an elucidation of something I suggested in the dedication itself.

For Ricky was indeed a Wonder Rabbi—as it occurs to me, so were both Stuart and Oliver as well. (All three of them partook of that hallowed tradition.) Like any Wonder Rabbi, Ricky seemed to shed marvels at every turn, dispensing lessons all the while, but always embedding those teachings in a history of other such teachings, the precious legacies of prior masters. But also like every Wonder Rabbi, he didn't just evince marvels, he embodied them, was himself a marvel, becoming the very stuff of stories as he lived, painstakingly fashioning himself into another link in that chain of consequence, as if by yet further magic. I could intone here as to how much he will be missed, how much all three of them will be missed (which of course they all three will be), but that's not exactly the case—because those stories will outlive them all and probably us all as well. And maybe that in the end, as Zohar Shimmel would have known, is the whole point of the exercise.

Hallelujah and amen.

Illusionist with Circassian Spirit

A MEDLEY OF FURTHER IMAGES
FROM ZOHAR STUDIOS

Absent-Minded Soothsayer

Surgeon with Scenic Saw

Itinerant Phrenologist

Pointillist Painter

History of Dread: A Guide for the Perplexed

Humboldt's Parrot

The Songbird and the Sharpshooter

LAWRENCE WESCHLER (born 1952, in Van Nuys, California), a graduate of Cowell College of the University of California at Santa Cruz (1974), was for over twenty years (1981-2002) a staff writer at *The New Yorker*, where his work shuttled between political tragedies and cultural comedies. From 2001 through 2014 he was the director, now emeritus, of the New York Institute for the Humanities at NYU, where he also taught a graduate course in "The Fiction of Nonfiction." He has also been the artistic director, also now emeritus, of the Chicago Humanities Festival and was a sometime curator of Bill T Jones's New York Live Ideas annual festival. Over the years he has been a contributing editor at *McSweeney's*, *The Threepenny Review*, and the *Virginia Quarterly Review*, and has contributed regularly to the *New York Times Magazine*, *The Atlantic Monthly*, *Vanity Fair*, *The Believer*, *Harper's* and NPR. He is the author of coming on twenty books. For more, see his website at www.lawrenceweschler.com, and sample his substack fortnightly, *Wondercabinet*, at lawrenceweschler.substack.com.

A Trove of Zohars
by Lawrence Weschler

First North American Edition

Library of Congress Control Number: 2022940460

ISBN 978-1-955125-19-2

Printed at The Studley Press, Dalton, Massachusetts

Vladimir Nabokov, photograph by
Horst Tappe, Horst Tappe Foundation/Granger
Rebbe Melvin Brooks, photograph by
Eric Roberts, Sygma/Getty Images

Hat & Beard Press books are distributed to the trade by
Publishers Group West
Berkeley, CA 94710
Phone (866) 400-5351

10 9 8 7 6 5 4 3 2 1

www.hatandbeard.com